A HANDBOOK ON THE CARE OF PAINTINGS

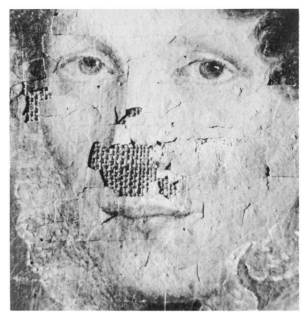

FIG. 1. Detail from a neglected nineteenth-century American portrait on fabric, showing loss to the support. Your paintings can only look to you for their care.

A Handbook on the Care of Paintings

by CAROLINE K. KECK

Published for the
American Association for State and Local History
by Watson-Guptill Publications, New York

Dedicated to
Nelga Young and The Ledgelets,
Bermuda.

❧ Contents

◆◈ Acknowledgements

The author gratefully acknowledges the invaluable secretarial assistance of Mrs. Margaret C. Peters. For the diagrams of various forms of structural deterioration in paintings, thanks are due to Mr. Per Guldbeck. With one exception, all illustrations come from our files of photographic records of treatment. The original photographs were made by Mr. Sheldon Keck, Mr. Milo Stewart, and Mr. Charles Uht. Permission to reproduce these photographs was given by the various owners of the paintings. The single photographic exception is the series illustrating the storage vault at Hartwick College which was especially made at my request by the College. All data which is reproduced has been credited to its authors. Sincere appreciation is given to Mr. Sheldon Keck and Mr. Frederick L. Rath, Jr., for their criticism of the manuscript, and to the American Association for State and Local History for the opportunity to communicate these thoughts to you.

Caroline K. Keck
Cooperstown, New York
October, 1965

❧ Introduction

THE older I get the more certain I am that to Americans some of the paintings to be found in historic houses are more important than Picassos. My husband, Sheldon Keck, and I have spent the past thirty years caring for paintings. We have worked on famous paintings, ancient paintings, modern paintings, in and out of museums. I think historical societies tend to disparage what they own. There is a prevalent feeling that any really good picture would have been given to a fine arts museum. Perhaps so. Certainly in our land, masterpieces are seldom discovered in local settings. Our history doesn't go back that far. Nevertheless not every artistic creation is important for aesthetic reasons, many are irreplaceable artifacts: American documents of fact or fancy which give form to our whole culture. These paintings fill gaps in our history with rich detail and without them we would have an unbalanced view of our ancestors, even of ourselves.

Most local collections grew up in community attics. For reason of affection or disuse people deposited their belongings in regional store-rooms, forming a hoard of Americana that varies in quality and interest. The quantity seems overwhelming, but time and neglect, misjudgment,

ignorance and accidents are taking a terrible toll. Systematic exploration is long overdue. So is a program for preservation. We need to train a painting rescue corps if we are to save the gems. And gems I am convinced we have, however inept, beat-up, overpainted and begrimed some of these pictures appear to the casual glance.

Portraits of staunch forebears, pictures of landscapes, towns, farms and scenes now gone or altered, still life paintings and "memento mori" mirror your history and mine and belong to the heritage of all our children. Each painting is unique. It is created by an artist in a special period and in a special environment. It is not, said Heraclitus, possible to step twice into the same river. What an artifact has to tell us should not be blurred, or censored, or to the best of our ability, altered by ignorance. No replica is ever the same as an original. It may satisfy the generation that produces it, because every age sees with its own eyes, but exactly for that reason, it will not satisfy ensuing generations. An accepted fake, for instance, in one period, is obviously false to another period. It is our responsibility to pass along true documents, not suggested images or ghostly mockeries. The last thing state and local history buffs want to do is present their audience with false ideas of our past. Unfortunately, the current state of too many paintings in your collections reflect embarrassment and a rebuke. Unless we want to pass on a heritage which is a cold carrion, the work of an undertaker's hand, the tailoring of restorers, we must face the serious task of re-examination.

Few historical items are new although in rare cases they may be pristine. Most gifts reach your collection worn out, repaired, or damaged. How can you know where to begin or what to do once you start? I think you will have to teach yourself to do the spade work, learn how to separate what is rare from what is plentiful, find out how to estimate physical condition, and raise the funds to buy skilled help in your plans for optimum preservation. You have at hand information on the care of many items; this handbook intends to start you on the right path where your paintings are concerned.

Pictures, like a member of your family, are seldom seen without being specially noticed. They hang on the wall. You may take them down and repaint the wall but you rarely think of reconditioning the pictures. So much art far outlasts the person who creates it, that we think of art as permanent. It isn't. Paintings are composed of materials subject, as are all

materials, to the processes of deterioration. From the day a picture is painted it changes steadily with the phenomenon of the seasons, day and night, cycles of sunlight and temperature, attendant shifts in condensation and evaporation. The changes are both chemical and physical and many are the result of atmosphere itself. There are also man-made damages. These are malpractice in restoration, accidents, hazards of handling, poor framing, vandalism, and not least of all, inherent vice in the composition of a painting on the part of the artist who used improper mixtures. The goal of painting preservation is to extend the life of a picture by supplying the right element in the right place at the right time and in the right degree.

We have never liked the word "restoration." It seems to connote only improved appearance. Appearance is vital, paintings are made to be looked at, but many a painting visually satisfying is in dire need of succor! A woman who has cancer may look better after a trip to the beauty parlor, but she still has cancer. Dangers must be recognized, and this requires special understanding. If you can save a picture before it goes to pieces, it won't need to be "restored," you can "preserve" it. The proverbial stitch in time keeps the statement true and saves extra expense. Taking care of paintings is not a one-time job. Short of catastrophe, neither paintings nor people change appreciably overnight. They age, become desiccated, inexorably. We must learn to recognize the danger signs. Painting conservation, like housekeeping, never comes to an end, but it is worth every hour and every cent you spend on it. If you bear with me, I believe you will agree.

Lord Duveen, that supersalesman of art treasures, persuaded his wealthy clients to invest in pictures because he held, unlike race horses they required no food and did not die, and unlike yachts they required no crews nor fuel and did not sink. He promoted paintings as gilt-edged securities without upkeep. He sold expensive and marvelous pictures with this theory, but the theory is utterly false. Paintings can die, can sink into nothing, if they are deprived of upkeep.

A renowned Italian collector told me a story which I will never forget, nor has he. Years ago he and his father heard by the grapevine that some peasants had discovered what was purported to be a masterpiece in an outbuilding of an old estate on which they labored. They were secreting it in hope of a fortune. By a complicated series of messages and proposals, these gentlemen were allowed to visit the place, but no amount of

argument permitted them to seek out the painting from where it had been concealed. The peasants insisted that my friend and his father stay outside the buildings and wait for the painting to be brought to them. So there they sat, he told me, on a bench in a cluttered farmyard watching until the farmer and his wife came from behind their house carrying between them a great wooden slab. Approaching the bench, the two peasants raised the panel to a vertical position and for one wonderful moment there was a painting of a Madonna and Child with angels. Then the poor porters stood their find on the ground with a great thump and the jar sheered off the entire surface to a pile of brilliant dust on the bare earth, leaving still visible the broken inscription along the bottom edge . . . "Vivarini," one of the great Venetian painters of the fifteenth century!

Ah ha, you say, but of course if a painting has been left in some fallen down shack, exposed to wind and rain, naturally it can't last. Quite true, but last it had, fragile and vulnerable, until ignorant mishandling lost it to us forever.

Even without mishandling, tragedy occurs. In the early days of Hitler, a tiny exquisite Raphael was spirited away by its German Jewish owners to safety in Switzerland. On the strength of its great value a bank advanced moneys for the owners to take refuge in America, holding the painting for collateral in their vault. After the war, arrangements were made to sell the painting here and repay the loan. The Swiss bank sent the Raphael over with a personal representative. Amid hushed assemblage of lawyers, bankers, art lovers, the seals were broken, the forms were signed and the treasured parcel unwrapped. As the last tissues were removed the onlookers gasped, for the paint lay in a pile of dry particles and the wooden support was quite naked. There had been no crude mishandling as with the Vivarini, no careless shock. The environment of the bank vault was no proper atmosphere for this painting, the wood had moved in protest and shed its glorious skin.

These were both masterpieces lost without intent, by misunderstanding, by costly ignorance. I have heard and seen tragedies like these again and again. There is still another type. An institution owned a portrait labeled by them as an eighteenth-century founding father. Because a section of the surface flaked off they sent the painting to a colleague of ours. It so happened that we visited his studio shortly after the painting had arrived. The surface showed a clumsily repainted three-quarter length portrait

done at best estimate within the past fifty years and in no way related to eighteenth-century American painting save in imagination. Our colleague had taken an X ray of the head and one of the hands. The X rays showed that beneath this nasty twentieth-century smear were the remains of a finely executed eighteenth-century face and hand, with two tear damages visible near the hand. Reconstruction of the crime was fairly easy. A genuine eighteenth-century portrait had been neglected and abused, it had reached the hands of a "restorer" who glued on a lining to repair the rips and then repainted the whole picture to save time and to conceal his awkward repairs. To make it look "old" he slathered on brown varnish, and strange as it may seem, the person for whom he did the work accepted the odd mess he produced, or perhaps disliked it without knowing what was wrong. The institution obviously had received the portrait in its present state with no knowledge of the alteration. The quality of the hidden portrait was so good that all three of us spent hours completing a full technical examination, reaching the happy conclusion that over 75 per cent of the original portrait was intact underneath its murderous repaint and warranted the time and expense required to reveal it, reline the painting and compensate properly for the 25 per cent loss. We don't encounter a buried city of Troy every day, we were excited!

What happened was pathetic. The curator received our joint report with outrage. HOW, he demanded, could we dare to suggest "dissolving away their most valuable portrait." He wanted to know what reasons we had for believing that the man discovered in our X rays was even the same person as the one now on the surface? He drew no clue from our report that the surface was only twentieth-century overpaint, had no validity whatsoever for an eighteenth-century attribution. He failed to understand that the surface he saw was a layer false in time, at best an imitation of some known portrait of the founding father, but one which no stretch of fact could ever make into an historical document. True that although what was evident in the X rays was genuine eighteenth-century work, we could not guarantee that it was a portrait of the personage in question. Identity of subject is a matter of provenance, records, and scholarship. But ignorance and stupidity do not excuse the dishonesty of such misrepresentation as in this case, the visible portrait was utterly wrong. I am glad to assure you that after lengthy explanations and patient insistence we did get our point across. The repaint was removed, the eighteenth-century

American portrait was uncovered, and the search for identity begun to everyone's eventual satisfaction.

These are didactic tales. It is far easier to collect and display with no weight of responsibility for what is exhibited. But I have yet to meet a gardener who doesn't find more delight in his garden as he learns more about horticulture. Doing a job well is one of the great pleasures in life. The key is to familiarize one's self with the problem at hand, to learn to understand, to evaluate and to interpret correctly. Such habits soon become routine practice. When new duties have to be faced, it is only the beginning that seems burdensome. Taking care of paintings is a combination of new knowledge, sound habits, and detective work. I will try to give you the basic knowledge and indicate the necessary habits—you get the fun out of being the detective.

ONE : *Preliminary Survey*

ON page 129 is a list of painting conservators whom I recommend. If your association can afford the expense, select from this list the person who is geographically nearest you and request a professional survey of your collection. This will save time, and in the long run, money. If you accompany the conservator while the survey is being made you will learn much more, much faster and much better than you will from reading this book. Professional conservators will charge travel expenses and a per diem fee, but it costs nothing to find out how much. If, when you make your initial request, you can enumerate the paintings which should be checked, stating whether they appear to be in a reasonably good or in a poor state, your selected professional can give a more accurate estimate of the time involved and subsequent total cost of the survey.

Every conservator on my list I know personally and can vouch for. There are other conservators whose work I admire but who to the best of my current knowledge are not in a position to assume additional employment. There are many excellent practitioners whose work I do not happen to know. There are also persons practicing restoration whose work I know of and whom I do not recommend. If any conservators are recommended to you, please seek objective opinion and if possible view work they have done, reports they have made, before putting your possessions in their hands.

Conservation of paintings is not a licensed profession. Anyone may hang out a shingle claiming to be a restorer and take money for butchering art objects. Knowledge, training and integrity vary. While expensive work is not always the best, cheap work invariably proves to be costly. Until we have legal controls and educational standards of practice, you must weigh the evidence and use your own judgment.

Anyone surveying a collection of paintings should be required to present to you a written report, listing and describing each item accurately, explaining its condition, detailing the advised treatment, and including a full estimate of all costs of treatment and any insurance involved. Without laboratory investigation exact estimates cannot be made for all treatments. A maximum and minimum figure is customary, as is an indication of optional treatments where several courses of action are feasible. A qualified conservator will explain to you why one treatment might be wiser than another or why the condition of a painting might only merit minor treatment. He is concerned with preservation and will work with you for the benefit of your collection instead of concentrating on urging you to spend as much money as possible.

Never let anyone try to "snow you" with jargon. Technical terminology is normal shop talk among professionals—all of us must increase our working language when we turn to a new field. But there is absolutely no excuse for failure to describe the condition of a painting, the problems presented, and the proposed procedure in plain, comprehensible terms.

You may not have extra funds. All right, we can do the job together. Not the conservation work—NO LAYMAN SHOULD EVER TRY THIS—but the survey. With a small expenditure, some help from me, a lot of patience and study from you, this is feasible.

We need a room. Ideally, we need a room which has good light and will be undisturbed. If such choice space is not available, try to find a location where there is at least one bare wall and no thoroughfare. The last thing we want is to create hazards. I will list essential needs; some you can borrow, others it would be helpful to purchase. Speak to a businessman on your board. He will be more sympathetic than the bankers or the lawyers. Businessmen appreciate the value of taking inventory and are familiar with the waste in depreciation. Bankers and lawyers make excellent collectors and researchers but they seem instinctively to hedge against disturbing any *status quo*. We can use them after the adventure has begun

and we have some progress to show for it. If four businessmen would give $25.00 apiece we would have our nest egg.

Essential requirements for an initial survey of paintings

A strong bare table: if none is available a 4 × 6 foot plywood can be put on saw-horses, and both plywood and horses can be returned later.

A good portable light source with a flexible shaft. Either a gooseneck lamp with a 150–200 watt bulb or a TENSOR light. TENSOR bulbs give brilliant illumination (cost about 15¢ each). Either type light could be borrowed.

A vacuum cleaner with a hose extension and a soft round brush nozzle. Borrow this if you must, but it is wise to own one for future use.

3 pairs of pliers: snub-nose, long-nose and cutting pliers. Buy these.

A tack hammer, square-headed and flat-sided. Buy.

A good quality screwdriver. Buy.

A metal tape measure. Buy.

A pair of good scissors. Buy.

An awl. Buy.

A heavy-duty electric extension cord. Buy if possible.

A strong pocket knife. Buy.

A package of 4 × 6 inch index cards, lined on one side, blank on the other. Buy.

About six bottle corks in good state.

A dozen brass mending plates, 2½–3 inches long. Buy in hardware or dime store. (These have holes drilled in them.)

1 box of blue steel or nickel-plated wood screws #4, ½-inch. Buy.

1 box of blue steel or nickel-plated wood screws, #4, ¾-inch. Buy.

1 package, 25-ft. multiple strand picture wire. Buy.

1 dozen half-inch screw-eyes. Buy.

A thin, flat sculptor's spatula, slightly curved and tapered at one end. If you can't find this, get a long-bladed palette knife. Buy.

A 3- or 4-inch wide soft bristle brush, camel or badger hair. Buy.

One roll of 42-inch wide glassine paper or one roll of newsprint paper. Buy.

2 pieces of strong cardboard or masonite about 30 × 40 inches. Buy or borrow.

1 roll of self-adhesive felt; FLAN is one of the trade-names for this. Buy.

A container of ELMER'S GLUE-ALL or any other synthetic white glue. Buy.

Ask your lumberyard or carpenter to cut for you (it doesn't have to be clean wood) 6 sections of 2 × 4 inch lumber in 22-inch lengths and 4 sections of the same stock lumber in 18-inch lengths.

2 yards of inexpensive corduroy, 30 inches wide, color irrelevant. Buy.

A staple gun. Borrow. (Or a box of #6 carpet tacks. Buy.)

Ask around for some worn-out mattress protectors, or buy a pound of cheap cotton batting.

Purchase the hand-magnifier which you find easiest to look through. Bausch & Lomb sell a wide selection of these in optical stores and camera shops. It need not be an expensive one.

If you have $30 left buy a portable ultraviolet unit. Available from Stroblite Co., 75 West 45th Street, New York, N.Y., or from Fischer Scientific Co., 633 Greenwich Street, New York, N.Y., or any other branch of Fischer Scientific.

We also need the temporary use of a ladder and a second pair of hands.

Padded Blocks

The first thing to do is to make the ten sections of the 2 × 4 lumber which have been cut to size into padded handling blocks. If you were able to find some old mattress protector material (otherwise use the cotton batting), spread it out on the table top, place a block of each length—one 18-inch and one 22-inch—on the stuff and mark outlines with a black crayon or a felt pencil. Cut for each wooden block two thicknesses of material to exact size and one thickness double-sized, to be used folded over. To make up the 18-inch blocks you will need eight pieces of padding material measuring 4 × 18 inches and four pieces of padding measuring about 11 × 19 inches; and for the 22-inch blocks, twelve pieces of padding measuring 4 × 22 inches and six pieces measuring about 11 × 23 inches. On top of each block fit first the two single pieces of padding and then cover these with the double piece, folded over—it should overlap slightly. If you cut your corduroy into sections approximately 4 inches larger in each dimension (8 × 22 inches, and 8 × 26 inches) they will cover the padding adequately leaving an excess to turn under where you attach it to the block. Fit the corduroy covering snugly to the padding, turn under the

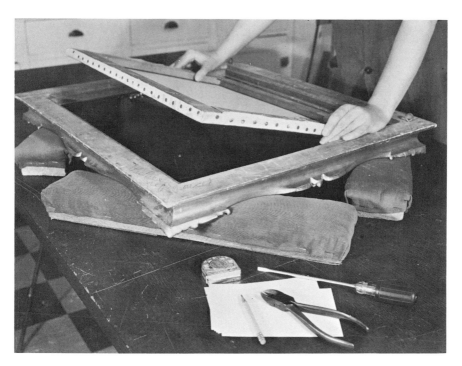

FIG. 2. Padded blocks serving to protect the corners of an elaborate frame while the picture it contained is being removed for examination.

edges, and tack or staple it to the four sides of the blocks. See Fig. 2. This work may take several hours, but it is worth all the time and trouble. When you have made these handling blocks you will have taken the first step toward practical care of your collection. Museums use quantities of these pads in varying lengths and store them on top of each other when not in use.

Removing a Picture from the Wall

A painting, like a pane of glass, can be broken by a blow from either side. Once you remove a picture from its hanging wall you expose it to punctures, scratches, knocks and falls. Frames are heavier than they look. Never try to take down a picture when you are alone. You may find yourself in an untenable position faced with saving either yourself or the picture. Beware of the hanging hooks and the wires. They can slash down

at both you and the picture. Make sure the ladder is steady and never try to jerk the painting clear of its wall. To prepare for the unexpected prevents you from suffering sad consequences.

Once I delivered a "first-aid" conservation talk to the staff of Old Sturbridge Village as part in a series of refresher discussions before reopening day. Frank Spinney, who was then director, told me I had mentioned every point he hoped I would but added laughingly that there really weren't dangers from loose hooks at Old Sturbridge. The next morning we met for our annual picture-to-picture check of their collection, and the first painting he lifted off its wall for me to examine pulled the hook and a piece of plaster out with the picture wire. I must admit we subsequently removed and replaced some thirty-five other paintings with no such disaster, but it proves that even the most efficiently run museum can have weak spots in plaster. So, please, from the beginning of our work, proceed with caution.

If you have those confounded picture lights attached to frames, make sure your second pair of hands is next to you. Both of you take the picture down, stand the bottom edge of the frame on two of the padded blocks, one of you steady the frame, and the other unscrew the light fixture and remove it and its snaky cord to a place of safety. I violently dislike these contraptions, but many of us must put up with them for the present. The first year I came to teach at the New York State Historical Association in Cooperstown, I showed them a bulged-out section on a painting caused by excess light cord from one of these illuminators. In polite disbelief the curator had the painting removed from the wall. But I was right. Extra cordage had been neatly rolled together, taped into a bundle and concealed behind the canvas. The fabric was not strong enough to resist the constant pressure, it bellied out in protest. What was obvious to me had gone unnoticed because this particular cause and effect was unknown.

No one except the mentally ill ever willfully damages a painting. Neglect comes from ignorance, not indifference. Your collection has been in sight but out of mind. It needs to be introduced to you in a new light, several new lights. We have to start with a preliminary exercise.

The Preliminaries of Examination

Select two paintings, one on fabric and one on a solid support—wood or

cardboard, academy board—and two watercolors, or one watercolor and a map, or a black and white. Pick items which need attention but which are not in your opinion too fragile for you to handle safely. Keep the size small—under 30 × 40 inches. These objects are to be your first explorations. Remove all four items from their walls and stack them on pairs of the longer padded blocks, leaning them against an unencumbered wall space. Slant them, as shown in Fig. 3, face towards the wall with your strong cardboards or masonite sheets intervening when you stack two pictures on top of the same pair of pads. The pads act to cushion the bottom edge, keep the painting secure against slipping, and let you rest an elaborate frame on its strongest portion rather than on the vulnerable and often extended corners. Remove all wires—if they are in a poor state discard them—but use a tape measure to record their length before you undo them so that when you come to rehang the pictures you can readjust new (or the same) wires to their original lengths. Note down the measurement on your index card which you will fill with information about the painting as you proceed to examine it. Never crowd your pads. Use them for the safe temporary storage they are planned to offer.

It is easier to examine a painting out of its frame, but not every painting

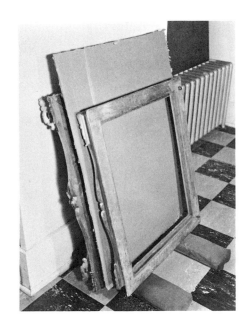

FIG. 3. Empty frames stacked correctly on padded blocks, slanted against a bare wall with a cardboard separating them from direct contact with each other.

may be unframed with safety. A broken or badly damaged painting will be damaged further by inexpert handling. A painting, brittle to the touch, which has deep ripples in its surface, may have torn free from its stretcher and be held in place only by the pressure of the frame. In a general survey there are always paintings which can be examined on their walls. Use common sense and choose deliberately because unframing a painting is very instructive.

Unframing a Painting

Start with the painting on canvas. Place the four shorter length padded blocks on the bare table top and adjust them by eye so that presumably they will serve as diagonal supports to each corner of the framed painting. Unless the picture is small, ask help in lifting it up and putting it in place on the pads, face down. Then lift each corner of the frame and readjust the diagonally placed blocks so that nothing seesaws. Line up the vacuum cleaner, tape measure, screwdriver, pliers, scissors, index cards and a pencil.

With few exceptions, paintings are held in their frames by exasperating connections. You will be astounded at the dirt, the accumulation of wires, nails, crumbling papers. If the picture has a known title and artist, an identifying number, jot this down on the index card. Crowd as much information on one card as you can—two or more cards tend to get misplaced in the shuffle. Copy off any and all information you find on the back of the painting and on the back of the frame. As things get cleaner you will be able to decipher more clearly. However, occasionally an old label or an old legend written on a paper tape vanishes into a vacuum cleaner, and what it said is lost irrevocably. Remove any paper or board which might cover the back of the canvas. Locate the nails or other means of attachment between the frame and the painting and remove these. Easier said than done. You may need to pry up—VERY GENTLY—nail heads with the tip of your screwdriver before you can grasp and pull them out with one of your pliers. If your tools tend to indent or massacre the adjacent wood, fold a spare index card in quarters and use it to shield the area around the stubborn nail. It can be a grim battle, but the less strain, the less harm. Get help if you need it from a carpenter.

When all the nails are removed, throw them promptly into a wastebasket. Many a forgotten nail, left unnoticed on a table top, has scratched its

mean signature into a picture. Any cross-wires should have been removed already; there should be no visible restraint when you lift the painting out of its frame, as illustrated in Fig. 2. Place it, by itself, face out, slanted against the bare wall on another pair of your padded blocks—you see why we made so many of these! Vacuum the frame, back and front, and return it to the original pair of blocks. Take the four corner protecting blocks off the table and clean the surface thoroughly. Roll out a piece of glassine or newsprint paper on top of the cleaned table and cut off a section somewhat larger than the dimensions of your picture. Put the roll of paper back in a corner where it won't fall over suddenly and scare the heart out of you—thinking it was a painting! If your cut sheet of paper shows a strong curl, pick it up by the two ends and flip it over: it will lie flat. Get your painting. Carry it with the flat of your palms against its edges, as though it were a panel freshly varnished on both sides. Place it face up on top of the clean paper.

Measuring a Picture

If there was no known identification, describe the subject on your little record card so you can identify it later. Pull out the tape measure and place the end tip over the upper edge of your painting, measure the height at the middle, then shift the tape to a corner and check your measurement. It may vary as much as half an inch or more. Note down on your file card the larger measurement. Repeat process to obtain width measurement. It is international museum practice to list height measurement first and width measurement second. Once you acquire the habit you need no longer write out the words. When a measurement is made without removing the painting from its frame, it gives merely the dimensions of what is visible and is called "sight" measure. In ordering frames, you tell the framer both the actual measurement of the item and what you want exposed to view, the "sight" measurement as well. This determines the depth of the groove, or "rabbet" into which the picture fits at the reverse of the front opening of a frame. Without a proper rabbet a painting cannot stay in place in its frame; unless the rabbet is large enough to allow for movement it may damage the picture. As you may have already discovered, dimensions of a painting can change!

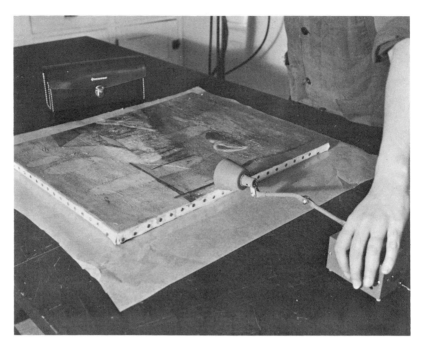

FIG. 4. Using a TENSOR "Foldaway" unit for examining a picture surface in raking light.

Examining a Picture

Plug into the extension cord your portable examining light and take pains to make sure the extension cord will not act to trip you and that your examining light rests securely in ample space on the table top. Study the surface of the picture to discover if a signature is visible; if there is one, copy it down and locate it, as "TCL" (top center left) or "BR" (bottom right). Twist the light source down (as is shown in Fig. 4) until its beam is nearly parallel to the face of the painting. As the beam of light slants across the surface, slowly move the light from a position at the top of the painting to one at the bottom edge. This scrutiny is called examination in "raking" light because the beam of light literally rakes the surface for irregularities. You will see the silhouettes of all the parts of the painting which are out of plane. It is akin to the effect of a setting sun on landscape—everything stands out sharply. Raking light shows bulges and dents, rips and cuts, lifting paint, losses you never noticed, and it serves to

tell you whether you have a sound or a sick painting. When you find a spot which scares you, if you were able to buy the hand-magnifier, use it to enlarge your vision of that area. Do not press down a blister, do not pick at a curl of paint, do not push back a bulge. Only very recent paint is still flexible; old paint is brittle and can break as easily as brown newspaper. Repeat your study, raking the light in the intersecting direction. Turn the painting around if this is easier for you.

On all canvas paintings with exposed fabric in the back, there is a veritable collection envelope between the bottom strip of the wooden stretcher and the canvas. This pocket catches and holds all falling matter, bits of plaster, pine needles, rolls of dust, loose stretcher keys. While the mass of oddities is increasing, the painting is drying out. All too soon the envelope of canvas is forced to conform to the shapes pressing against it. Paint films crack. The surface flakes off. Such a collection of foreign matter is the cause and the explanation for the great proportion of loss, and all those irregularities along bottom edges of canvas paintings. Fig. 5 is a common example.

Stand your picture on end, upside down, the reverse towards you. Gently tap the top edge. An assortment of evils will fall out. While you dislodge this accumulation, slant the top of the painting towards you; otherwise it will all slide down into the opposite pocket. Not everything dislodges easily; therefore nudge stubborn bits with your flat spatula or long-bladed palette knife. Be VERY CAREFUL to keep the blade parallel to the fabric or it will puncture! If a triangular wedge of wood drops out, save it. This wedge is a stretcher key, which belongs in a slot inside the corner joint and serves to expand the wooden frame over which the canvas is stretched.

Put the painting back against the wall on a private pair of pads and slant it securely. Vacuum away the dirt you removed, and if the glassine or newsprint paper is soiled or torn, throw it away and lay out a fresh sheet. Never be parsimonious with these materials; they exist to help you protect the painting. When you have made sure that the table top is smooth and clean again, bring back the picture and place it face down this time, on top of the paper protection. Do NOT do this if during your raking light examination you found reason to believe any direct contact with the surface would result in loss. Take the next step only if you feel certain it will inflict no additional damage.

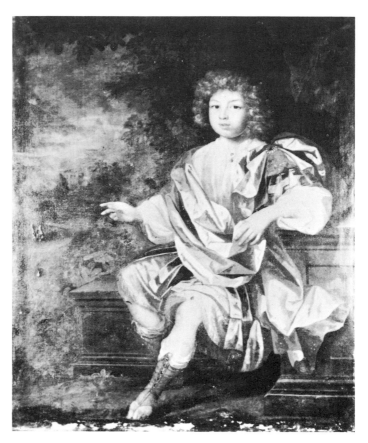

FIG. 5. Portrait of Edward Hill IVth—American, eighteenth-century oil on canvas, owned by Shirley Plantation, Charles City, Va. Condition before treatment showing the excessive damages usually found along the bottom edges of paintings on fabric.

Re-attach the vacuum cleaner and pass the round soft brush nozzle over the exposed fabric of the back of the picture. Do not press down hard but gently clean away the load of dust caught in the threads. Avoid any brittle paper labels, they suck into a vacuum instantly. Go over the wooden parts too. Vacuuming can bring to light dirt-encrusted inscriptions on the back of the canvas and on the wooden stretcher strips. Be on the lookout for these. Copy off all information you discover onto your record card. If you found a loose stretcher key, locate its empty slot and replace the key. Originally there may have been one or two keys at every inner joint, both

corner and crossbar joints of the stretcher. Insert the pointed end and push the key back into its slot with thumb pressure. Provided the painting has no tears, no acute lifting up of paint, is securely attached to its stretcher on all four sides, and seems slack, you may nudge the key in further with your tack hammer. To protect the canvas from accidental hammer damage, slide two index cards behind the key while you tap it down. In larger paintings index cards are too small to shield the fabric; there we use thin pieces of cardboard—the kind laundries send back in shirts will do. A canvas painting is supposed to be taut, its surface in one plane. When, in response to atmospheric changes and other causes, the fabric expands and goes slack, it rests back against the inner rims of the wooden stretcher and these rims make bend marks outlining their edges in marks on the face of the painting. Whenever a canvas painting is forced to bend, it will eventually crack.

Bring back your flexible light source. Set it securely on the table and direct the beam at yourself. Holding the painting in both hands, face towards you, move it back and forth in front of the light as if you were using it to shield your eyes. Structural cracks or ruptures are obvious wherever the light shows through. On all complete ruptures—actual breaks in the material—you will see uninterrupted lines of light; on cracks where the paint layers are broken but not the canvas, you will see lines of light with fiber connections in them. If it seems to you that there is an elaborate network of lighted lines, when you study your painting in "transmitted light" examination, your picture is literally being held together by the threads of the fabric and is in a very fragile state. When no light shows through in this form of study but you still notice cracks on the surface in your raking light examination, you can deduce that some of the layers which compose your painting are broken but one or more layers are still continuous. In this case, whatever losses or lifting you noticed on the surface are called "interlayer," which means that as yet they are not complete structural losses. The nature of a loss, how many layers of a painting are involved in it, serve to guide a conservator in advising treatment of repair. Fig. 6 and Fig. 7 indicate how revealing examination in transmitted light can be. The two photographs combine to show how carelessness in hammering in a stretcher key caused multiple structural cracks in a paint film! When you know how to look and how to interpret what you see, not very many faults go undetected.

FIG. 6. (L.) Detail of a delicate picture surface in raking light, showing several mechanical damages with their resulting cracking.

FIG. 7. (R.) The same area of the same painting shown in transmitted light examination. The diagonal damages all lead to the top of a key in the corner of the stretcher, and were clearly caused by the side of the hammer striking against the back of the canvas. Other cracks came from pressure damages. All show complete fracture of the structure.

Place your painting back on the table top, face up. If you were able to make the purchase of the ultraviolet unit and have some means for darkening your room, attach it now to the extension cord. Please be very careful at this point. Do not rush into a self-created accident; THINK—leave no obstacles which might trip you in the dark. When you have everything under control, press the button on the ultraviolet unit and wait a minute for it to warm up—it takes a few seconds—then pass its beam slowly over the face of your painting. The violet glow will do the picture no harm, but it will make your eyes hurt if you look directly at the source. You may see on the surface the milky-yellow or greenish-yellow fluorescence of varnish; you may see dark purple blotches of repaint; you may see streak marks from previous cleanings. Exact interpretation of

ultraviolet is rarely cut and dried, even for experts, for response is so varied. This means of scientific examination causes materials to fluoresce according to their special properties but no table of identification is possible for the layman. Some varnish fluoresces milky; other varnishes have no fluorescence; paint mixed with varnish medium fluoresces as if it were only varnish; repaint and exposed dirt can both register as dark purple; and so forth. Just as we never use the information derived from any one type of examination alone to assist in diagnosis, so we combine the evidence shown by ultraviolet with the evidence shown by other forms of investigation to arrive at a judged and balanced analysis of condition. To rely on just one bit of information would be as incorrect in forming a decision regarding a painting as it would be for a doctor to take only your blood pressure when he is making a physical examination of you.

I wanted you to see the appearance of your painting under ultraviolet because it opens your mind to the vast range of nonvisible examinations we can make. There are other equally exciting ways to study pictures in the laboratory. As you learn more, your own continued experience with the use of ultraviolet in conjunction with the rest of your visual research will increase your ability to detect repaint and repair in paintings. Your portable ultraviolet will come to serve you as a watchdog, it will confirm your suspicions. It is one of the art detective's best friends.

Why are we spending so much time studying our picture? Because if the surface of a painting is fragile, if its structure is in a precarious state, it cannot, must not be cleaned before it is consolidated. When the layers of a painting are solid, continuous without disruption, dirt and discolored films can be removed with comparative ease. But when the examination shows that the picture is physically weak, starting to peel away like so much sunburn, even the gentle pressure of a cotton swab will carry off part of the picture! (Figs. 8, 9, 10, 11) I have purposely postponed our consideration of how the subject matter looks until we have found out all we could about its skeleton and body. We are interested in preservation, in having a complete picture to clean. The trip to the beauty parlor should follow the urgent operation, not precede it. Unless someone has made the kind of study you have just carried out, it is very difficult for them to understand why cleaning is not the first step in care. Alas, under dangerous conditions, it can be fatal. Remember, we are doing this together. I am trying to make statements upon which you can rely. In

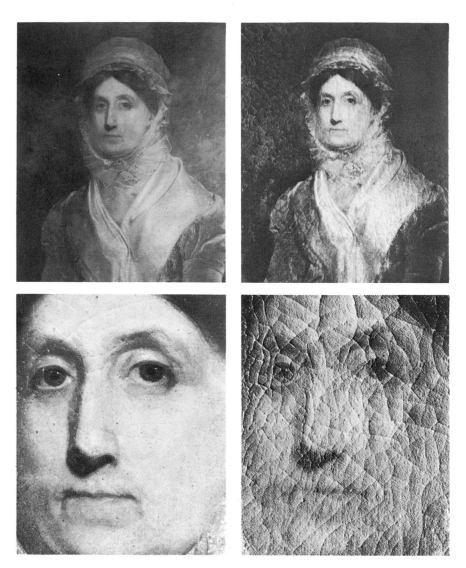

FIG. 8. (Top L.) Portrait of Mrs. Isaac Wharton, by Sully, painted in 1825, collection of Mrs. Ryder Henry. Condition before treatment seen in normal lighting.

FIG. 9. (Top R.) The same, seen in raking light examination.

FIG. 10. (Bottom L.) Detail of the same, face seen in normal lighting.

FIG. 11. (Bottom R.) Detail of the same, the face seen in raking light examination. Obviously no attempt should be made to clean such a fragile surface until it is reconsolidated, a cotton cleaning swab, however lightly used, would remove tiny sections of lifted paint.

almost everything I tell you, there are unique exceptions. I am relying on your common sense in deciding when the information I give you should be followed to the letter and when it applies in part only. Select those instructions which fit the problem at hand.

The topmost surface of most paintings, like anything else in a house, is usually covered with a film of dust. Always remove this with a soft brush, never use a rag or a feather duster. Threads from a rag or feathers from a duster catch in the tiny lifted parts of a picture surface and tend to pull them off. Take the wide camel or badger hair brush I asked you to buy, and pass it gently back and forth in both directions over the face of your painting. We do not use the vacuum cleaner brush because the pull of the vacuum is too strong—it might suck up some of the surface. Also the bristles of vacuum brushes are so stiff they can make scratches in a varnish. Embedded grime will not brush away. Paintings can be discolored by dirt, by darkened varnish and by stains; they can also be discolored by chemical alterations in the paint layers. Most paintings can be cleaned after a careful analysis of what kind of obscuring films are discoloring them, but quite obviously the substances used to remove such films must be ones which will not harm the layers underneath. We need to understand the nature of the portion we want to remove, how to do this safely, so safely that in cleaning we uncover, without damaging, the picture we are preserving. This procedure is very rarely simple. There are clues which indicate how the picture looked when it was clean. Often at the very edge of paintings where its surface has been hidden under the rabbet of the frame, you will notice a marked difference in the colors. Or, there may be places where dirt and browned varnish have flecked off, and brighter, fresher tones are visible. Use your magnifier to check such clues. Remember varnish is colorless when first applied, light and air oxidize it to brown tones, air-borne dirt can combine with varnish, and with unvarnished paint to begrime surfaces until a picture is almost obscured. Fleshtones, white clouds, white materials offer a handy gauge for the probable extent of discoloration. Contrast between clean and uncleaned portions of a picture can be so extreme that they seem like night and day as they do in Fig. 12, 13, but even on these you can see a slight difference between the body of the scene and that small edge which was protected by the rabbet of the frame.

When you have made all your observations, record them. Take your

 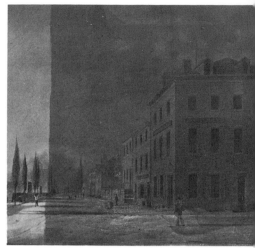

FIG. 12. (L.) Portrait of a Gentleman of the Schuyler family, by John Watson, collection of Yale University Art Gallery, Mabel Brady Garvan Collection. Condition during removal of a very dark varnish film.

FIG. 13. (R.) "Broadway looking north at Grand Street," by R. Bond, Collection of the New York Public Library. Condition during the removal of a dense film of grime.

index card which already has the measurements, information copied from the stretcher strips, labels, all obvious identification, and turn it over to its blank side. Draw a large tick-tack-toe and superimpose on this criss-cross the outlined shape of the painting—oblong, square, oval, round—make it as large as the tick-tack-toe permits. Using the lines of the tick-tack-toe as if they were latitude and longitude line intervals on a geography map, indicate the approximate locations within the shape of the painting of all the conditions discovered during the examination of the face of the picture. Invent your own system of symbols. A dot could be a hole, a solid line a tear, a dotted line a scratch, a shaded area a bulge. Turn the picture over front and back as you need to refresh your memory. Hold it parallel to you and study the edge where the canvas turns over the wooden strips; there may be signs of two fabrics. If you see indications of a lower and an upper fabric, this means that at some point in its life, the painting has been strengthened with a lining—a secondary support of material. We use the term "lining" in the same sense as it is used in referring to a coat or suit lining. And like those in clothes, linings on canvas paintings wear out

too. The length of their useful life depends on the quality of linen used, how well it has been attached, and with what type of adhesive. Of course, as you will see for yourself later on, all these factors can be nullified by an improper environment which will act to destroy, with a horrid speed, even the best substances. For your immediate purposes, jot down the fact that there may be a lining. Put down on your index card EVERYTHING you observe about your painting—the labels, the inscriptions, damages, lifted paint, cracks, discolored surface, patches, lining—all are a part of the painting's history and have a bearing in determining its future.

By now you should be better acquainted. You have studied this picture under normal light, raking light, magnification, transmitted light, and seen its surface under ultraviolet fluorescence. The index card bears your first survey notes. Later on you can copy and organize your notes, but the important thing at this stage is to have it all written down for reference. If you used more than one card be sure to clip them together so nothing gets lost. This is a valuable dossier.

Put the painting back on its storage pads, safely slanted against the wall and turn your attention to its frame. If you feel up to it, repair any minor splits or broken sections with ELMER's GLUE-ALL. If you feel the task is beyond your skill, be sure to collect any free sections and place them in a little box or a clasp envelope, and mark it clearly with the name or number of the painting. When you can afford to, give the frame with the collected parts to a frame repairman. If there is no problem of frame damage, arrange four of your padded blocks, as you did in the beginning of our work to cushion the corners of your frame, and place it on them, face down. Test whether the painting fits easily. If you replaced a missing key, or tightened the canvas by keying out, it is possible that the painting may now be too large for the opening. This is almost always true if the frame fitted the painting tightly without allowing any space for dimensional changes. Do not try to gouge out a larger rabbet—this is no task for an amateur—ask help from a carpenter or cabinetmaker who owns the tools needed to do this work without damage to the frame. A frame may look solid from the back, but the majority of them are ever so fragile on their faces. We certainly have no need to add to our expenses by inflicting unnecessary damage.

If the painting fits the rabbet, return it to safety on its padded block and inspect the rabbet. Run your finger tip—lightly!—around this little groove

to locate any splintering sections or rough spots. The FLAN, which I suggested that you buy, can serve to cover these irregularities and protect the rim of your painting when we reframe it. If you were unable to find this self-adhesive felt, use ordinary felt and attach thin strips of it to the little rabbet with small applications of ELMER's GLUE-ALL. Always cut your little strips of felt narrower than the wood you need to cover as the material spreads slightly when it is patted into place. This procedure gives temporary protection, but is very helpful in preserving the edge of your painting from needless wear and tear. Make sure, if you use ELMER's, that the adhesive is completely dry before you place the painting against the felt. Half an hour should be sufficient time to allow. Fit the painting in place and, if there is ample space, shift it as needed to equalize the extra space on its four sides in their relation to the walls of the rabbet. Place four of the brass mending plates, two on each of the longer side of the painting, to bridge the space between the solid wood of the frame and the wood of the stretcher strips. These are seldom on the same level. Use the snub-nosed pliers to bend the flexible brass straps into whatever modification of a "Z" curve will make the straps conform snugly. Make sure you check the thickness of your frame at the point of contact for the metal strap, and select an appropriate length screw for attachment. Too long a screw can puncture the front of the frame. Using an awl to start the hole, place your selected screw in the drill holes of the brass mending plates and tighten the metal straps which you have adjusted to fit. Although there are cases when conservators do not attach both ends of the strap, I advise in this case that you attach the straps to both the frame and to the wooden stretcher strips; it will give your painting greater security in its frame. For further security, if there is ample space in the frame, say one-fourth to one-half inch between the edge of the painting and the wall of the rabbet, slice off sections of the bottle corks to fit these spaces and wedge them in; two on a side will do the job, and the cork is a pliable material. Set these cork wedges with a drop each of ELMER's GLUE-ALL where they touch the frame, in order that these little wedges will not shift about when you move the frame to rehang it.

Examine the screw-eyes. These should neither be loose in their holes nor bent nor excessively rusted. Replace any you consider in poor state (again beware of using too long a screw-eye and puncturing the front of your frame). Replace the wires if these are worn out—you took their measurements when you started so this is noted down on your file card and

presents no problem. If the painting hung from moulding hooks, check these. Now get your second pair of hands because someone should hold the picture while you climb the ladder with the wires and their hooks in your hands. Handle the adjustment of these possible foes yourself and check their security before you release the picture in place on its wall. You do know a lot more about this painting than you did when you took it down. If you are short on time or tired, do not drive yourself to go on. But if you decide to stop work now, please make sure that the stacked pictures still unexamined will be undisturbed in your absence.

Examining Cardboard or Wooden Paintings

The next painting we will examine is the one painted on wood or cardboard. There will be differences. In unframing this picture you may recognize more signs of damage from nails. With canvas paintings, at least when nails are driven through the stretcher bars to attach them to their frame, the picture itself is seldom harmed. In wooden panels you may find such nails have caused splits clear through to the picture surface. Be extra careful in removing these; it will take skill and patience and infuriate you that they were hammered in so thoughtlessly. Some panel pictures are made of more than one section of wood. Their joints may have become dismembered (as the adhesive dried out in time), and removal from the frame can leave them separated. If the panel should come free into parts, make no attempt to reframe it after your examination. Get a conservator to rejoin the sections, and until this can be done store the separated parts face up on a shelf. You may find that a seemingly flat panel will change shape as soon as you take it out of its frame. Wood has a will of its own; an initial curve or warp tends to return. Leave such a panel alone and ask for professional help in reframing. Wood may be persuaded but never forced; it rebels against pressure by splitting.

When you record the measurements of a panel painting, note down as the third dimension, the thickness of the panel. Also measure the length of each crack and mark down the date this measurement was made. When you reach the stage of an annual checkup for your collection, the changes in length or breadth of such cracks in wood will warn you of improper environmental conditions in housing. Examination of a panel painting in transmitted light reveals only those cracks which are complete, but what is a partial split in wood one year may show up as a complete split the next

year. You may conclude that paintings on wood are less disturbing to examine; they are, alas, our most serious problems of preservation. Like your closet doors which stick in damp weather and close easily in dry air, all wood, definitely including pictures painted on wood, reacts dimensionally to absorption and release of air-borne moisture. It is this constant movement which results in damaged paint films and long cracks of curled-up surface.

If your painting on solid support is thin wood, academy board, or one of the other prepared artist's panels, never press hard against it when you remove the framing nails. These paintings can look strong and be as weak as brittle paper. I once saw a curator of paintings, before I could stop him, pick up a nineteenth-century American picture on academy board by its corner. It snapped off in his hand some four inches into the picture. Handle such paintings with respect. You are apt to find their edges scraped and scratched, their corners dog-eared.

Some wooden panels, even academy boards, are backed with a cradle. A cradle is a honeycomb of wooden slats and was originally attached to the reverse to prevent the picture from warping. Fortunately for you, cradles are uncommon in American paintings, although very common in European ones. In our steam-heated world instead of preserving a picture plane, attachment of a cradle can force the panel to split or to "corduroy," conforming like a washboard to the alternate intervals of glued strips and empty spaces on its reverse. Where this conformation has occurred we remove cradles as soon as possible.

When you have made your survey and written down your observations, reframing your picture on the solid support is slightly different. You want a minimum of pressure from your flexible metal mending plate, you do NOT screw down the end of the strap which holds the panel, and you allow for shifting space within the frame. Wood moves. Since we anticipate motion, cushioning the inner face of the rabbet with felt is vitally important to prevent damage to the picture's edges. I prefer that you leave out any wedges of cork. I make no attempt to turn you into a framer anymore than I would to turn you into a conservator. Experts in both these tasks are needed to effect permanent correction of trouble. As the guardian of your collection you have improved your framing on an individual picture and given it temporary security; subsequent work is essential—we both know this.

Art on Paper

Mr. Keck and I do not specialize in treating objects of art on paper. The problems these present demand different skills from those which we normally practice. Since we have worked with such artifacts in the past and are deeply concerned with their welfare, I can give you rules of thumb concerning their care. You will receive much more telling information from a specialist in paper conservation. But for purposes of this survey, we must include these items and I will tell you what I feel is essential as a starting point in your care of them.

Use no corner pads when you examine a watercolor behind glass, unless by a fluke your watercolor is framed in an elaborate frame. Glass bends with pressure; bend it too far and it breaks. Clear the worktable and put down your clean paper. Place the picture flat against this, glass side down. You are likely to find the entire back covered with a paper glued to the edges of the frame. Make sure to copy off any information on this paper backing and then tear it off. If you can tear it off so as to save sections with writing for your records, so much the better, but this same paper would under no circumstances be reused for a backing so don't worry about destroying it. You will NOT reframe artifacts on paper yourself, except very temporarily as I will show you; this must be done by a specialist. Brass straps—except in unique circumstances—are not used to secure watercolors, drawings or prints in their frames, and a special piece of equipment is employed by framers to drive in the tiny brads which normally serve to keep the picture in its frame. When you are removing these tiny nails or the little metal wedges often used in their place, be very careful not to tear what they secure and also to remove every last one of them. On the metal tabs, it is sometimes possible merely to bend them back out of the way and not remove them completely. Do NOT try to lift the picture out from the back. After it is free, very gently and carefully turn the whole over and lift the frame with its glass off the picture. In this way you will not cause damage. The important lesson to be learned in unframing a watercolor, map or drawing, is the relationship between the artifact on paper and the materials which surround it. This relationship you must see for yourself in order to realize the dangers and know how to prevent them.

As you work, try to keep one portion of the table free and clean, so that

as soon as you take the picture apart, you can concentrate on its safety. It is unlikely that your paper artifact has varnish protection. Once out from behind glass, it will be naked and vulnerable. As soon as you have lifted off the frame and the glass, lift—very gently—the watercolor, by itself or in its mat if attached, and place it face up at the clean end of the table. Cover the face with a sheet of glassine paper or clean newsprint. Your immediate interest is the layers which were behind the face, which may be cedar shingle, cardboard, beaverboard, or thick paper. They are expendable but very, very informative. Test corners to see how easily they might break. Look for streaks and stains, changes in color, and spots of mold— these can be brown "foxing," or greenish grey circles of varying dimension. Merely for your own information, jot down the number and state of any or all of these layers, If any one of them is clean and reasonably firm, save it.

Vacuum away any dirt you created and then examine your work of art on paper. Use the flexible light to give you good illumination, raking light study may show tears, old repairs, even insect damage on the surface, as well as indentations and irregularities in the paper. There is very rarely any lifting, such as you found in the paintings. This structure is a different type, as we will see when we discuss structure. The magnifier may show details and the ultraviolet may clarify repairs or damages, but with paper there is another very amazing state.

Paper is a sensitive material; it picks up faults from its neighbors. On your watercolor, hunt for any echoes of stains and spots which you may have seen on the backing materials. They will be fainter but quite similar in form and shape. If your artifact has a mat and it is removable, lift it free. Measurements of art on paper are correctly made when they are the exact size of the paper which bears the design; they should not include the mat or any backing board. You should note down on your index card whether the watercolor or drawing hangs free from its immediate support, whether it is attached and if it is, how. Is it attached all over, along one or several sides, with bits of separate paper (hinges) at several points? All this information belongs in your record. Is the surface dirty, stained, wrinkled, torn, repaired, blistered, bulging? Make your observations and write them down. When you feel you have seen all you can, cover the surface again with the clean paper protection and go to the other end of the table to examine the glass and frame. Turn the inside of the glass

toward you and use your flexible light to see if there is any image of the picture visible on the inner side of the glass. You may find a very faint imprint, even traces of color. This phenomenon is called "offsetting" and is due to friction plus static electricity. No object of art should ever be placed in direct contact with glass; good framers use a separator strip to keep a margin of safety. If the inside of the glass shows a marked film of dust, your picture was not properly sealed. Everything you detect which was wrong you can act to prevent in the future.

When there are no serious damages on your watercolor, follow these directions: clean the glass, inside and out, let it dry thoroughly to discourage mold and replace the picture inside the frame, gently. If you can get ACID FREE white blotters (such as photographers use), cut one to size and place it between the reverse of your watercolor and any reasonably sound piece of backing you saved. Hold this temporarily in the frame with 1½-inch-wide masking tape and store it face up on a shelf until you can afford a professional reframing. But please wait until we discuss good materials and the care of paper, so you will know what to have done. Remember, masking tape is TEMPORARY, its adhesive deteriorates in time, and the tape will peel off. Do not wait too long for the reframing and do not let the artifact be handled in ignorance of its fragile state.

I requested you to remove for study two objects framed under glass and now I beg you to take the time to unframe and examine the second one. With two items the chances are better that one or both will provide you with a variety of improper conditions. A single example may not demonstrate all the faults I hope you will observe and all the harm they can cause. Until you have seen these with your own eyes you will not be ready to take action.

My whole idea in having you undertake this strenuous and dusty labor has been to arouse your interest in my crusade. My colleagues would be almost unanimous in reproaching me for putting the cart before the horse. I have asked you to look before I have told you what you are really seeing. But I believe all laymen become curious in proportion to their experience and that information which satisfies curiosity has meaning. Too many academic lectures whether spoken or written go in one ear and out the other. If you have performed all the chores I set for you, you must be filled with impatient queries. In which case, you are ready for the next chapters. They are loaded with answers.

TWO : *Anatomy of Paintings: Pastel, Watercolor, Gouache*

TO dramatize the plea for my concern with paintings, think of them for a moment as if they were icebergs. All the stories about icebergs emphasize that the part seen, above the water, is not more than one-eighth of a very dangerous whole whose concealed mass is seven-eighths invisible but deadly. When navigators ignore the hidden mass of an iceberg, tragedy can follow. The same is true for paintings; the parts beyond our normal line of vision are both the greater proportion of their whole and also the parts which determine whether a painting lasts or whether it disintegrates. Fortunately, unlike an iceberg a painting is not lethal, but if our mind's eye ignores what we do not see when we look at a picture, tragedy does follow.

When you examined your paintings in raking light, you saw their third dimension, depth. No matter how thin a picture may seem, it has a laminated structure like a NABISCO wafer. The relation between the amount exposed to your glance and the amount of this structure which is hidden is unbelievable at first. Study the two cross-sections, Fig. 14 and Fig. 15, which are minute structure slices, cut from edges of paintings and mounted on their sides to show their multiple layers. Fig. 14 illustrates the

26

structure of a painting on a wooden support—and not all the thickness of the wood was included in this section because it was lost by damage—the curved void is part of a worm hole, so you may judge how greatly this is enlarged. The paint and varnish layers are hardly noticeable so much of the space is filled up by the white ground and the remains of the wood. Fig. 15 illustrates a cross-section of a painting on fabric. You see the nub ends of the threads, again the white ground filling in the interstices of the weave, and a very small part occupied by the dark surface films above the ground. It is unlikely that you would ever require cross-sections made from the paintings in your collection. We use this method of laboratory study when we do intensive research into the composition of the different materials in a problematical paint structure. Cross-sections reveal the anatomy of a painting as nothing else can, they prove the point we try to clarify—that the visible pictorial surface is not much more than a skin covering a complex corpus.

When a doctor decides on a course for cure, he aligns his knowledge of the individual characteristics diagnosed for a special patient with his identification of the ailment. If he should try to treat the ailment as isolated from the person who suffers from it, quite possibly his operation might be successful but the human being turned into a zombie. Paintings are as unique as people. Each picture has its particular combination of layers, each layer has its particular combination of materials, and each

 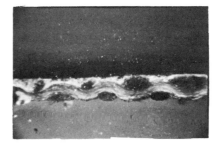

FIG. 14. (L.) Greatly magnified cross-section of a painting on a wooden support, the curve is part of a worm-hole and only a portion of the wooden panel is shown in this tiny fragment.

FIG. 15. (R.) Greatly magnified cross-section of a painting on fabric support, the lighting makes the painted surface seem thicker in proportion than it really is!

material has its particular physical and chemical properties with particular behavior patterns. An artist may paint two pictures at the same time and with identical materials, but one may become exposed to different circumstances of environment—hung above a fireplace, on a damp wall—and this difference in the atmosphere of its existence will alter the nature of the entire structure from that of its mate. We have found this to be true more than once. For each painting there is a right way to make it last longer in a state as near as possible to the original intent of the artist. But the painting must make the rules for its own course of treatment. There is no bag of tricks, no panacea. Decision on how repair will be undertaken has to follow careful study and analysis, for no treatment should make the picture unrecognizable.

We, the conservators, exist to serve you. However, unless you know your collection as intimately as you know your family, you cannot acquire the vigilance needed to prevent yourself from being victimized and your collection from being butchered by unscrupulous supersalesmen. In this task, like your ancestors, you must pioneer. You will find books written on how artists paint, fewer books written on the analysis and treatment of paintings, and as yet no books devoted to the preservation problems of indigenous American paintings. In this handbook I am not trying to burden you with unnecessary facts, but to include all those which are essential to our common understanding.

Aside from contemporary art—assemblages and "Pop Art" with their junk-pile fantasies—the structures of most paintings fall into well-tabulated categories. In all pictures, starting from the top—the part seen—we find at least two or more of the following layers. For instance, pastels and watercolors have only two layers in structure, while oil paintings can have as many as seven. Following are brief descriptions and a discussion of the structural layers from the visible surface down:

1. SURFACE FILM: A transparent protective coating of varnish (or occasionally wax) usually brushed over a dried paint film by someone, not the artist. It serves to make the reflection uniform and saturates the colors, giving them the brilliance which they had when fresh and may have lost in their drying.

2. PAINT FILM: The design layer, the picture part. It is made up from pigments mixed with a fluid vehicle (binding material) in such a way

as to spread easily when manipulated. Paint is supposed to adhere, wet or dry, to the material on top of which it is spread. As the vehicle dries, it binds the pigment to the surface. With few exceptions (chemical instability or incompatibility) the same pigments appear in all painting techniques. Pigment is the finely divided coloring matter, reduced to powder by grinding. There are inorganic pigments (natural earths, treated minerals, manufactured compounds), and organic pigments (vegetable and animal dyes, synthetics). Each has special properties, as do the vehicles.

3. PRIMING: An initial tone for the design, the "imprimatura," which may be executed in colored (red, brown, grey) pigment in a binding medium and sometimes exists between the paint film and the ground.

4. GROUND (often called priming) : A mixture of pigment and binding medium used to fill in the physical irregularities in the support and give the artist an evenly absorbing surface on which to paint. There are gesso and chalk grounds mixed with glues, oil grounds and emulsion grounds. Most paintings have grounds, few have both ground and priming.

5. SIZING: A layer of size (animal glue, resin, thin shellac) isolates the absorbent support from the often equally absorbent ground. This invisible and usually forgotten layer keeps all those above it from soaking into the support.

6. SUPPORT: Artists have used stone, plaster, metal, wood, ivory, fiber boards, paper, and fabrics as the carriers for their paint films. Each rigid or nonrigid support has its own properties and characteristic reaction to changes in atmosphere, chemical changes, and hazards of handling.

7. AUXILIARY SUPPORT: For fabric supports this is usually a wooden stretcher or strainer; for rigid supports it can be a mount or a cradle. It is the very last part down from the surface, hidden from view but often the origin of many physical changes which occur in a painting's surface.

You can see the relation of these layers as they are illustrated in Fig. 16, which diagrams an "exploded" painting.

The name of a technique of painting is usually related to the binding medium. The following list includes a good many which you are not apt

to encounter in your collection along with several which you will find in quantity.

PASTEL—Pigment and chalk with gum tragacanth.

FRESCO—Lime plaster and sand and pigment in water.

ENCAUSTIC—Pigment in beeswax or wax-resin.

WATERCOLOR—Pigment in gum arabic—transparent.

GOUACHE—Pigment and chalk in gum arabic—opaque.

DISTEMPER—Pigment in animal glue.

CASEIN—Pigment in casein—cheese-glue.

TEMPERA—Pigment in yolk of egg.

GLAIR—Pigment in white of egg.

OIL—Pigment in a drying oil—linseed, poppy, walnut.

OIL-RESIN—Pigment in oil-resin mixtures.

MIXED TECHNIQUES—Combination of any of the above in the same painting. Waterglass, Ethyl Silicates, lacquers, enamels, synthetic resin emulsions, are newer mediums and not as yet apt to show up in your collections. Pastels, watercolors, gouaches, and oil paintings will be discussed here. If you discover other techniques among your paintings, look up information on them in one of the books listed in our bibliography on page 128. Some techniques are easy to recognize visually, others even experts must identify with chemical tests. It is important for you to become sufficiently informed regarding the identification of technique because it determines structure and, subsequently, our responsibilities in preserving a painting.

Pastel

A painting in pastel is the simplest of all picture structures. There are only two layers—the support and the design layer. The sticks of colored chalk are used to create a design by mechanical pressure. Infinitesimal bits of the chalked pigment, held together by the gum tragacanth, are caught in the fibers of the support as the artist applies them to create his picture. Friction makes the stick of pastel powder off, roughness of texture keeps the colors where they are placed. There is no adhesive. It is the most delicate of all techniques. The picture stays wonderfully fresh, but if you have the misfortune to rub against or shake a pastel, the color powders off. It is possible to "fix" pastels with a spray of sticky, quick-drying liquid often used to fix charcoal drawings in art school. However, good pastels are

never sprayed with even the best fixatives since this can change their appearance completely. Pastels are kept under glass; they are never varnished. The supports are usually fine quality paper; sometimes parchment and white silk prepared with size or rough ground are used. The pastel portions can never be cleaned, the supports can be done occasionally. But never let anyone except a qualified expert in paper conservation attempt cleaning. I cannot overemphasize how fragile this type of painting is. Destruction is so easy. If a pastel is hung on a wall where a door is apt to slam shut, the chalk will shake free with the shock, and the picture will get fainter and fainter while its chalk pigments collect in a line of rainbow dust at the bottom of the frame! When pastels are framed, they must be separated from the glass which protects them by a well-planned separator strip or they will transfer to the inside of the glass, either by slight contact due to the bulging of their support or by static electricity. The marked electrostatic characteristics of plexiglas, even when treated, makes any reframing of pastels with this material for travel security a serious hazard. Pastels simply should not travel. If you are compelled by circumstances to lend one of your pastels, pack with excessive cushioning and still anticipate loss. But aside from man-made troubles, a properly framed pastel executed on a good paper support suffers no speedy deterioration.

Watercolors

Good paper, pure rag paper, is a fine material for a support and lasts well under normal conditions. In watercolors, we still have only two layers—the paper support and the design layer—but this time the pigment is bound to the support with an adhesive vehicle, water soluble gum arabic. A water color will not brush or shake off, it can dissolve away if accidentally wetted. It can, however, as a rule and under expert hands, be "washed" clean if soiled. This operation is delicate and requires skill but is by no means uncommon. Save in exceptional circumstances related to their physical condition, neither pastels nor watercolors should ever be mounted solid against a support. Plenty of them are, and these usually exhibit signs of decay because of this mounting. It is almost impossible to free a pastel from a bad mount, but easier with a watercolor. Both these forms of painting are kept best when they are hinged at the top and hang free. They should be hinged with good hinges, attached with good paste,

and hinged against an all rag "museum board" mount—but more about this later on.

Just as good quality paper lasts well, a poor grade wood pulp paper not only deteriorates rapidly but encourages the destruction of everything in contact with it. Cheap paper yellows, browns, unevenly or all over; it embrittles swiftly and crumbles to the touch. I sincerely hope, not for the welfare of the artifact but for what it must have shown you, that when you unframed your art on paper, you found streaks and staining echoed from one backing layer to another, and perhaps even all the way to the front of the picture itself. There was so much to be done in early America that few people had time to think much about the behavior of materials artists had to use. Nor did framers. In the nineteenth century, framers often backed their glazed pictures with cedar shingles. Time after time, these shingles have transferred the grain and knots in their nature, forming patterns of wavy lines and circles on the face of many lovely paper scenes. They bleed out in brown stains, interfering with the design and are very difficult to remove. Corrugated cardboard backs have the same nasty habit; their marks can be recognized as rills corresponding to the lines of corrugation in the cheap pulp board. Once you know what you are seeing, you will be able to detect the deep-rooted cause of such discolorations on many paper objects.

So-called museum board is of rag content, washed clean of chemical impurities. It serves its purpose excellently and is lasting. The difference in price between this and the next "best" grade board is very little. Insist that your framer use all rag museum board for every reframing you must have done. And beg, borrow, or steal funds to have any precious relic showing acute damage cleaned by an expert and correctly reframed. Neglected, the damage will inexorably increase and work to destroy the scene completely. As I hope you saw for yourself, paper has an amazing tendency to pick up any bad traits. With museum board there are no impurities, you may feel secure. Any substitute is a waste of money.

The browning of paper is a chemical and physical action caused by light and accelerated by the presence of heat and/or moisture. Watercolors and other art objects on paper are ultrasensitive to light damage. If they are exposed to direct sunlight they will fade. Exposure to any form of concentrated light, natural or artificial, increases their tendency to discolor and to embrittle. Remember, inks can fade as well as colors, and the

paper support may have unwashed impurities which will brown. How fast pulp browns under limited exposure was proven to us in our own laboratory. We had stored extra rolls of the cheap newsprint paper (which we use, as I suggested to you also, for occasional undersurface protection during examination and work) on a high shelf in a center studio lighted by fluorescent ceiling fixtures. The rolls were wrapped in a waxy blue paper, fairly thick. We took one roll down after about six months and found, as we unrolled it for use, a steadily repeating pattern of yellow interrupted with one small white spot. The intervals of yellow pattern corresponded with the side of the roll stored towards the ceiling fixture, and the white mark was that tiny part of the exposed curve protected from our ceiling light by the shadow of a shelf peg, which had been inserted to keep the rolls from falling down! We were really amazed because our fluorescent fixtures gave very diffuse light. Nevertheless in six months the paper had suffered this obvious deterioration. We made use of the roll to emphasize to pupils how very sensitive paper can be, and made our point vividly.

Now if that roll had been moved around the room it might not have yellowed, or at least yellowed more evenly and to a much less degree. In your historic house, display is perforce permanent, which means that wherever you have a concentrated light striking a display that display is exposed in exactly the same position to exactly the same cause of damage, day in and day out. It is dying by minutes because of where it is placed. Substitute a less fragile or less valuable item if you can. If such a change is not possible, rather than continue as an accessory before the fact, could you plan to avoid the crime by shading your treasure? European palaces have similar problems of permanent exhibition and often mount shade rollers above a light-sensitive picture, or hang curtains of tightly woven dark cloth which can be pulled open. I know this is not handsome in appearance, but it does save the picture, and the public will cooperate. There is an interesting factor in this cooperation. Visitors like to participate in perpetuating history; it gives them a share in an impressive responsibility for a small effort on their part. Many museums displaying paper artifacts in flat table cases affix coverings to the far side of the case to shade the contents between viewings. I have watched school children push back these covers, look with added respect at what was protected, and then ever so neatly replace the shading material and walk away with an

expression of serious importance. This is good. It arouses a sense of competence in an entire establishment.

There is one group of people from whom you can get help at a layman's level in handling the paper artifacts in your collection. These are stamp collectors. They know a lot about the care of paper items, they know about hinging, and they know about careful handling and storage of paper valuables. The great difference between stamp and paper conservation is that stamps are tiny; their colors are ink colors which behave in quite different fashion from watercolors; and methods used for cleaning and flattening stamps can rarely be applied with impunity to art on paper. But you will find that stamp collectors are familar with the use of glassine interleaves to protect designs on paper. In an emergency I would rather have a watercolor or a print hinged with a good stamp hinge than with any other kind of tape. A word of warning—never, *never*, NEVER use so-called "scotch tape" to hinge or mend paper. The manufacturers are in no way to blame for the endless damage done by the misuse of their product. They did not suggest this use, and they have published ample literature which should have warned people not to employ scotch tape for paper repair. However, it has been used again and again, and you will always find it has discolored the paper with an intensity in direct proportion to the length of time involved. To date we do not know how to reverse the action. The tape itself can be removed and should be at once before the yellowing gets worse with age, but the stain remains.

As you examine your paper objects you may find them torn, wrinkled, spotted with mold, nibbled by insects, stained from bad backings or from accidents, and dirtied. Minor smudges of dirt can be removed with soft gum erasers—be careful if these are over pencil or color. Serious dirt should always be cleaned away by a professional. (See page 131 of the appendix for a list of recommended paper conservators.) They too will give you estimates, records, and photographs on valuable items. The condition of the paper, the extent of the damages, and the complexity of the execution will determine costs. I believe careful reframing will be your most important step; this action will preserve what you have without additional destruction taking place while you collect money for the "restoration" of your favorites.

Watercolors are never varnished. They are shown behind glass. If varnish has been mistakenly applied and has not thoroughly oxidized your

paper, it is possible that it can be safely removed. Consult an expert. Unframed watercolors and prints should be stored flat, in folios of acid-free material, or in prepared, insect-proof drawers. Plenty of insects eat paper. Consult your paper conservator for advice on which type of fumigant is best both for your kind of collection and your kind of storage. An enamel or glass plate filled with paradichlorobenzine nuggets (moth crystals) placed in the empty space at the bottom of a chest of drawers helps diminish pest activity in an emergency. But do get advice. Remember to place sheets of glassine paper or MYLAR to cover the surfaces and protect the design from dirt, damage, and possible offsetting from friction. You want no loss in your storage.

Gouache

Only gouache is apt to flake off its support. Whether it flakes or not depends upon the care with which it is handled plus the balance of glue content as it relates to the thickness of the paint film. Some artists have painted heavily with gouache, using the mixture almost as if it were oil paint. This technique creates a fascinating texture but only too often the films do not adhere properly. Either one paint stroke will chip away from a lower one, or one or both will flake from the support as the gum contracts. There is not enough strength in the binding adhesive to hold one layer to the next one below it when strokes are piled on top of each other. The flaking and losses in gouache can be temporarily repaired and replaced, but a gouache which begins to chip will continue to do so, as your conservator will sorrowfully warn you.

All artifacts on paper should be isolated, either by the careful sealing in their frames or the equally careful lining of their storage conditions, from the gaseous impurities in the air. In our industrial areas the air we breathe is contaminated with sulphur dioxide, hydrogen sulphide, soot and dust. Moisture in the air combines with the free sulphur dioxide eventually to form sulfuric acid. It is the air-borne hydrogen sulphide which makes metals tarnish and blackens lead pigments in pictures. Gases and dirt can at least be kept away from art when they cannot be eliminated from the immediate atmosphere. Of course, if you have air-conditioning, air-filtering and windows with glass that filters out the harmful rays in light, you can rest easy. But Utopia is not close for all of us; we take preventative measures in the face of discomforts common to art and to man.

THREE : *Anatomy of Paintings: Oil on Fabric and Solid Supports*

IT has been my experience that the largest number of paintings in historic houses are oil paintings either on fabric or wood. I propose, therefore, to devote an extra amount of detail to their discussion. If I spend too long talking about any one phase of this part of our work, skip that which does not interest you and go on to what does. You have to remember that conservation of paintings is my profession, and I never fail to find it exciting. I believe you need to understand the nature of paintings, how to plan for their anticipated behavior, and how to cull information from their physical symptoms. It will be helpful for you to familiarize yourself with the terminology used to describe structure and deterioration. In the appendix (p.118) I have included a glossary which covers expressions in common use among conservators; you will note that certain conditions have several names but if you study the glossary in conjunction with the diagram on page 120, the terms will have meaning to you. The diagram shows the stages of deterioration and the most common faults to be found in paintings.

The hardest thing to keep in mind is that a picture is not static. It is an object in motion. Both wood and fabric undergo sympathetic dimensional

changes which follow changes in the moisture content of the air. These changes impose a rhythmical strain on the layers of a painting. You observed the effect of the cycle of motion when you examined your paintings and saw how this behavior caused the design to crack, the different layers to separate, lift, or flake off.

Let me tell you a story. During the 1930's in London at the National Gallery, a technician was employed whose sole task, during the eight months of the year when artificial heat was used, was to correct defects on paintings as they occurred. For the duration of World War II, the collection of the National Gallery was removed for safekeeping to a specially prepared repository. It had a temperature constant of 63°F and a relative humidity of 58 per cent. The first year the paintings were stored in their controlled atmosphere, the work of the technician was reduced to about one month's time. The longer the pictures remained in their secure environment, the less he had to repair, and after five years his visits became a mere formality. But when at the end of the war these pictures were returned to the gallery, except for those placed in the newly installed air-conditioned rooms, the flaking began again, and the technician had as many defects to repair as he had had before. We can repair damage, we can minimize violence of reaction with moisture barriers, but without controlled atmosphere we must realize that time works against us in more ways than one. Keep this fact in mind—pictures expand and contract as their materials absorb and release moisture; the more aged their materials become, the more dangerous is this cycle of motion.

Wood reacts to moisture with great strength of its own. Some warped panels have been in their state of warp since shortly after the paintings they support were completed. In such cases, the paint layers have conformed to the dimensional change, and they may show little damage from it—they were distorted while they were still young and flexible. Subsequent movement has only made slight alterations of the early bend. Other panels may have been exposed to atmospheric changes at a later stage in their ageing process, when the films carried on the wood had already begun to embrittle. When the wooden support of an aged painting is suddenly forced to move, the surface will show marked damage. Any disturbance of a status quo in a picture on wood, its removal from an atmosphere of normal moisture to a dry one, or vice versa, can have disastrous results. Many American panel paintings have lasted in fine state. Artists were

aware of the reactions of wood and prepared for them by coating the reverse of their panels with paint or other moisture barriers to seal both sides. Not all artists were so thoughtful, nor was every wooden picture exposed to severe changes. Our ancestors had no steam heat. When you receive a gift of a painting on a wooden support find out as much as you can about the circumstances of its previous housing and try not to subject it to sudden change. Do not put a panel from a damp location into a dry room. If you do, expect movement—and trouble! The persistence of wood is unbelievable. The amount of distortion, the shape of that distortion, and the suddenness of it, depends on a multitude of factors. The type of tree and from which part, which direction, a panel was cut are factors beyond your control. But you can control its environment. You can also control the way it is framed. If a wooden panel is tightly framed and cannot move freely, atmospheric changes will force it to check and even split. Moisture barriers can be applied to deter this inclination, but as yet we have no positive method for rendering the wood motionless during fluctuations of humidity. The best we can do is moderate these fluctuations.

Paintings on paperboards have the same surface problems generic to all oil paintings, but the boards themselves fall under the rule of paper deterioration. A paperboard will oxidize and crumble as it ages; it will buckle and disintegrate if wetted; it will rot fast if confronted with excessive heat. Corners and edges are the first portions to show weaknesses. Academy boards, prepared artist's cardboards with fabric adhered to their front, seem to be slightly more lasting than other forms of paperboard paintings.

Both wooden panels and paperboard pictures require special attention in relation to their frames. Attachment with nails can do extreme damage. These paintings have no auxiliary supports; hence, the nails pierce directly into their bodies. The nature of the material which supports the paint layers is the only difference between these oil paintings and others on fabric.

Auxiliary Supports

Oil paintings on fabric have a structure which can be more easily seen and therefore more clearly explained. I shall start with the lowest layer, the one furthest from view, the auxiliary support. If you find yourself

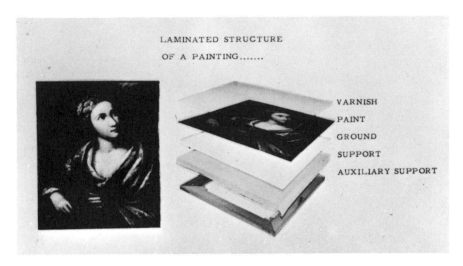

LAMINATED STRUCTURE
OF A PAINTING.......

VARNISH
PAINT
GROUND
SUPPORT
AUXILIARY SUPPORT

FIG. 16. **Chart showing the laminated structure of a painting—as if it could be exploded into its various layers.**

confused, look at Fig. 16, the "exploded painting" to refresh your memory. We are starting at the bottom. I purposely lead you from the front to the back and from the bottom to the top so often because I am anxious for you to think in terms of depth as opposed to merely height and width.

If the wooden frame over which the fabric is stretched has means for enlargement it is called a stretcher. If all the corners are nailed at their joints, glued together, or screwed tight, and the frame cannot be enlarged mechanically, it is called a strainer (Fig. 17). Many early American paintings are on strainers, handmade auxiliary supports, some crude and some carefully constructed. Many strainers are off-square, have warps in their members, breaks, bulging knotholes. Whatever malformations exist, they will be echoed in other parts of the painting. Very much like the rotten apple in the full barrel, a fault in the bottom-most stratum causes trouble throughout the entire structure.

When the fabric on a strainer expands with changes in atmosphere, it is forced to sag without succor. On a stretcher, when the painting goes slack or shows corner draws, the auxiliary support can be enlarged to pick up this change in dimension and once more serve to keep the fabric taut, in

FIG. 17. (L.) The small stretcher, shown with all keys in place and exposed on its inner face (the side which carries the canvas) is a twentieth-century commercial stretcher with mitred corners. Above it at the upper left, you can see how the keys can be forced into their slots to make the mitred corner open and enlarge the stretcher. Below is an example of a strainer, shown on its inner face, which carries the canvas, and clearly fastened at all joints. No enlargement of this would be possible.

FIG. 18. (R.) Butt-end stretchers have keys, as you can see in the example shown on its reverse side, the one you would see; note that the corners are not mitred. When you key these, they are forced to become irregular at their joints on two opposite sides as you can see in the extreme example of the outer stretcher, shown here without its keys to exaggerate what happens!

plane. To enlarge a stretcher is called "keying it out." Keys (which you may have seen when we examined our trial pictures) are small triangular wooden wedges which fit into prepared slots on the inner joints of a stretcher; the further in they are forced, the more—because of their wedge shape—they spread the stretcher members and increase the outer dimensions of the stretcher. Corner joints are of two types (Fig. 18). Mitre corners are constructed to separate in the shape of a "V" pointed out. Butt-end joints, which involve less carpentry work to make, literally "butt-out" of line when they are keyed, making a damaging protuberance at the corner of a stretcher frame and a subsequence distortion of surface plane. When a stretcher is a butt-end type, I feel it has questionable value

since attempts to enlarge its dimensions force an irregular expansion of the fabric it supports. When you detect corner draws on a painting which start, not from the exact corners but from a spot some two to three inches away from the corner, the canvas is apt to have been stretched on a butt-end auxiliary support. Do not try to key it out anymore; you will not get rid of the draws, and you may rip the picture. Never key out any painting when the fabric seems brittle; it has passed the point of safe response to stretching.

In the later part of the nineteenth century some elaborate and beautiful stretchers were cabinet-made for artists who could afford them. Asher B. Durand, Worthington Whittredge, John Kensett were among artists whose work I have seen on such stretchers. These are expertly constructed with thin cores of wood to protect the exposed fabric at the reverse, like tongue-and-groove panel walls. These stretchers were calculated to be keyed and made to last. Paintings on such stretchers are remarkably well preserved with the single exception of a tendency among those of large dimension to be frayed or split along their bottom tacking edge—owing no doubt to the additional weight of the stretcher as it rubbed against the rabbet of the frame. We always reuse such stretchers when we find them on paintings and send them on their way with metal stripping to protect the edges from this single fault. (This subject I will describe in the discussion of conservation treatment.)

Machine-made stretchers date from the twentieth century. I wish I could say that they were uniform. They should be, but men put the wood into the machines and do not consistently put it in level. Many machine-made stretchers have more irregularities than eighteenth-century strainers. We use a cabinet-made stretcher without keys, fitted with expansion bolts at the joints (Fig. 19). Each joint has one metal expansion bolt and two aluminum dowels for additional strength; the dowels are in the middle of the wood, invisible; the turnball of the expansion bolt is an open inlay ready to effect dimensional change at will by means of a nail-set or a similar tool which fits into its circle of tiny holes. These stretchers are very strong and solid and obviate the hazards of hammer blows. How much damage can be done by keying, careless contact of the hammer edge against the reverse of a canvas, is clearly indicated in Figs. 6 and 7. Here, in a corner detail of a delicate, light-colored, thinly painted picture, are five lines of crackle, ending in a bulge. The same area seen in transmitted light

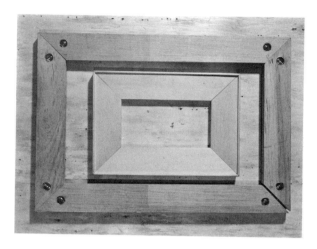

FIG. 19. Lebron expansion bolt stretchers are both mitred and extra strong at their joints. The small one is shown on its inner face, the one which carries the canvas. Note the gently rounded lip edge which cushions the turn of the tacking edge of the painting. The larger example is shown on its reverse, with its lower right corner opened to reveal the additional aluminum dowels inset either side of the expansion bolt. An ordinary nail-set can be used to turn the little bolts and expand the mitred corner joints.

proves that this harm was done when someone hammered in a key, five times, and hit the canvas with each blow! You can not be too careful.

We were not the first to think of using metal as a means to expand stretchers. At the turn of the century a stretcher was put on the market fitted at each joint with a patented mechanism of slotted metal. You may find some of these (see Fig. 20) in your collection. A hammer is needed to drive the contained wedge into the slot, expanding both members of the joint at one time. Use the hammer with caution and do not expand these stretchers too far; their corners have no additional strength and tend to split apart when enlarged to excess.

What I have described above are American-type auxiliary supports. There is a great variety of English and European forms. If you have a problem which I have not covered in listing stretchers, you can get information from your conservators. We have learned to recognize origin and approximate date in auxiliary supports the way the young recognize this in automobiles!

All pictures gossip. They are full of bits of information about their own

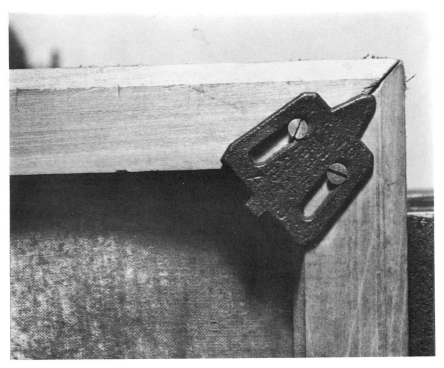

FIG. 20. Patented metal keying contraption to be found on stretchers of many turn-of-the-century canvas paintings.

histories, some of it accurate information and some of it fanciful. The reverse of a painting has been a favorite place for people to jot down names and dates, to paste labels, to tack envelopes, to place marks of ownership or bequest. Writing done with a crayon or a pencil can be faint and hard to decipher. If you suspect odd scratches have meaning, move your light to every conceivable position hunting for telltale reflections— with pencil, especially, marks can be fleeting. Photography with specially sensitive film occasionally brings results when a clue seems to warrant the expense and the eye is insufficient. Never discard a stretcher or a strainer until you have ferreted out its last secret.

In the eighteenth century, wooden pegs (Fig. 21) held fabric to stretchers. Hand-wrought and then machine-made nails followed. Nail chronology is discussed in Technical Leaflet 15 published by the American

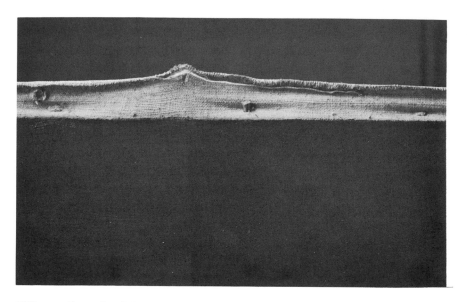

FIG. 21. Example of the wooden peg form of fabric attachment to be found on some eighteenth-century American paintings.

Association for State and Local History. It will give you appropriate tokens of recognition. Modern methods for attaching the fabric to the stretcher employ carpet tacks (blue steel, copper, aluminum, alloy) although I have seen roofing nails and thumb tacks also used in folk art pictures. The habit of using thin-cut nails and hammering them half-over, flat against the tacking edge, I have never seen in nineteenth-century American painting; it is fairly common in Italian paintings of that period and has reappeared both here and abroad in the twentieth century. Staples are twentieth century. Many is the time when we have been making a survey of a collection we will tell the curator that in our opinion a particular item is not an American painting. When he asks why, we tell him that the stretcher is from such and such a place in Europe or England. If you have reason to believe that a certain painting has never been off its stretcher, save it and some of the attachments until you can consult with someone who is able to identify them for you.

How do you know whether the picture is on its original stretcher or not? One sign is the amount of dirt and rust around the nail or tack heads.

Another sign is the presence of untenanted alternate holes along the tacking edge. On another stretcher, these holes once held tacks. When canvas paintings are restretched, it is customary to place the new tacks on the stronger, unused sections. So when you find this condition, keep in mind that your picture is in all likelihood NOT on its original stretcher and that all written information which appears on the wooden members is secondary source material. It may or may not have been copied correctly, it may purposely be false, or may be hearsay. A replaced stretcher must never be accepted as a primary source of information. Now if the design surface of your painting continues over a tacking edge, on one side, or more than one side, sometimes even on all sides, you may also presume that the stretcher is new and that the painting has been cut down from its original dimensions to fit its present stretcher. There will be only one set of holes, and these will hold the tacks, but the painting was obviously larger in size when it was painted—artists do not paint to the very edges of the fabric; those edges are turned over to attach the canvas to the stretcher. I have seen evidence of cut down pictures repeatedly in American folk art, both landscapes and portraits. Who cut them down? An artist? An owner? Why and how this can happen dawned on me once when I was visiting an artist friend while a client came to view a commissioned portrait. He liked the picture (rare with a portrait!), but complained that his wife had planned to hang it over the mantel and had already selected a frame she wanted, which meant that the portrait would have to be adjusted to fit the frame. As I recall they discussed that this would mean taking three inches off the width and two inches off the length! When I heard the artist agree to order a new stretcher for this smaller dimension, like a flash it came to me how often such adjustments must have been made in the past and how reasonable it was as an explanation for all those cut down paintings which had perplexed me. I feel sure that the greater proportion of our folk art was painted on order. Grant this, and the subsequent fitting of the size of the picture to a special frame or space follows with no mystery.

Suppose that the tacking edge reveals priming, drips, or brushstrokes covering the tack heads. This condition indicates that the artist himself prepared his support of fabric for the picture he proposed to create. Run over in your mind what you know about friends who paint. Today they buy at an art store the materials with which they will work—stretchers and

canvas. The canvas is available covered with a creamy-colored layer readied for the application of the paints. It is sold by the yard from rolls of merchandise stocked in different grades and widths and is called "pre-primed canvas." But in earlier days the painters who had to put together their own strainers also had to prepare the rest of their pre-picture structure. Whether they did or did not do this does not date their painted surfaces with irrevocable accuracy because the distance from source of supply and poor transit facilities could make materials scarce in some locations when they were plentiful in others. Pioneers had more vital necessities to carry than artist's materials. A folk painting was apt to be executed on fabric at hand—cotton cloth, mattress ticking, even opened-up bagging or burlap. Anyone who has handled oil paint, a house painter, a coach painter, a sign painter, all of them knew that the surface to be painted over must first be sealed against penetration of the oil or it would absorb too much. As you know from accidents, fabric is instantly penetrated by oil and grease and stained dark by the soaking. Unless you remove oily spots at once you may have learned the hard way that the stained area stiffens and then rots away. This is true with paintings too, and every now and then we come across one where the oil paint was applied—in ignorance or haste—directly on fabric, staining the reverse with a mirror image of the front, darkening the whole, and rendering the fabric finger-touch brittle. All fabric employed to support paintings requires an isolation layer between the cloth and the applied paints.

Sizing

This layer is called size. You can not see it, you tend to forget it, but it is the invisible giant in painting structure. When a piece of cloth gets wet, it shrinks. When you use gelatin, in cooking or mixing your own gesso putty, it swells with water. Most picture fabrics—including preprimed canvas—are first coated with a layer of water-soluble gelatin size. The size seals the fibers of the thread against penetration of oil. Because it envelopes the fibers completely, size determines how a picture fabric responds to dampness—and makes it expand! It is this layer, the sizing, which compels a canvas painting to behave in exactly the opposite way from other fabrics—to shrink with dryness, the way gelatin and glues do, and belly out with moisture. This explains why canvas pictures go "slack" in damp weather and "taut" in arid conditions.

Shellac has also been used by artists for sizing fabric, but gelatin size is the most commonly used, and has been for centuries. It works well as a seal, but it makes problems for you and for conservators. If a gelatin-sized canvas painting is soaked with water accidentally—or in amateur cleaning—the size will dissolve, and all the layers on top of it will crumble off. You may have been unfortunate enough to have seen this behavior. On the other hand, when a dent or a tear damages the canvas, conservators can employ limited dampening with controlled pressure to soften—but not dissolve—the size layer to flexibility and use its power to return the whole structure to a flat plane. Size also helps us when we are compelled to transfer a painting—literally to remove all the layers above the size to another support—which I will describe later.

Priming

When artists prepared their own picture fabrics after the layer of size, they brushed on a ground or priming coat, to fill in the interstices of the threads and to produce an even surface for painting. These are called "canvasses primed after stretching" and are easily recognizable. Artists are not too neat in preparation, they are too eager to get on to the part which excites them. Their brushes left drips of priming to run over tacking edges, too much and too hasty force sometimes pushed droplets of priming through larger thread openings to the reverse. All this is observable if you know what to look for. The priming coats were creamy, reddish, greyish, according to taste, and many eighteenth- and early nineteenth-century American paintings have these underneath their painted surfaces.

Fabric

The most common fabric for paintings is linen. Linen had to be imported—and still is. English canvas makers stamped what they sold with ink stencils bearing their trade-mark, firm name, address, and fabric quality number. The English canvas stamp I have selected to illustrate (Fig. 22) comes from the reverse of a double portrait, is said to be Dr. John Brewster and his second wife, painted by Dr. Brewster's son, John Brewster (Fig. 23) and owned by Old Sturbridge Village, Sturbridge Massachusetts. The first initial is illegible, the name is "Poole," the address "High Holborn," and "linnen" spelled with two "n's." There is a number (which we photographed in color after the stretcher was re-

 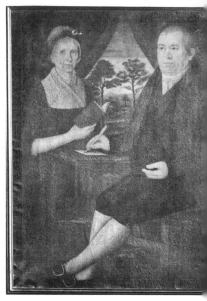

FIG. 22. (L.) An English canvas-maker's stencil from the reverse of the fabric used by John Brewster, for his portrait of his father and step-mother, Dr. & Mrs. John Brewster, painted in the mid-1790's, owned by Old Sturbridge Village, Sturbridge, Massachusetts.

FIG. 23. (R.) Raking-light photograph of the above portraits before treatment.

moved) in a tri-part box reading "1549/14/115" and the Crown, indicating royal appointment "J 29." British trade journal registry would give the date on which the firm of Poole was located in High Holborn, and research, using every scrap of the stamped stencil, could pinpoint the period of sale of this material for export. In this case, the research is not needed since art authorities have already placed the work in the 1790's, but with paintings of unknown origin, imagine what a bonanza the stencil would be. Stencils deserve your close attention as historians.

Linen came unprimed from England, as the Brewster fabric did, in the eighteenth century and for many decades later. As the commerce in pictures increased in this country, American firms went into the business of preparing artist's materials. They imported the linen, attached it to stretchers in popular dimensions, sized and primed the fabric. This work was done by hand, for profit, and many of the firms stamped their names

and addresses in stencils on the reverse of each canvas sold. Because towns grew rapidly, merchants were constantly moving from one business location to a better one. Their addresses changed, as did firm names. With each change, almost all the firms changed their stencils (except for Dechaux, who to my vast annoyance never included his address to indicate his moves, simply stencilling "Dechaux/ Artist's Materials/ New York" which helps hardly at all). Although we can never state categorically how soon AFTER purchase an artist made use of a prepared canvas, we can state beyond question that he could never have used it PRIOR to the date indicated by the name and address of a canvas stamp. Twice in my life have I known a canvas stamp to prove a painting was a fake, or at best a copy.

For instance, in the *New York Business Directory* for 1844–45, the firm of Theodore Kelley is listed under manufacturers of artist's materials at "79 Wooster." In Wilson's *Business Directory of New York City*, John F. Trow Pub., 1849–50, Theodore Kelley is listed as selling artists' materials at "rear 35½ Wooster." In the same directory for 1862 under artists' materials appears "Kelley, Theodore, 172 Greene." The painting on the face of the canvas stencilled with the Theodore Kelley stamp (illustrated Fig. 24), could not have been executed before Mr. Kelley moved to "35½ Wooster" although we do not know how long after that date the artist got around to using his purchase.*

So far we have discussed the auxiliary support, the fabric, the size, and priming; all of these are preparation for what is to be painted. The structure of a painting is very like linoleum, only far more complex.

*We have collected and recorded photographs of stencils for years and tried in vain to get some art scholar interested in tabulating the stencils against recorded address changes for listed firms. Recently a friend who shared our conviction that they are useful in authentication took on the chore as a hobby. I include his name and current address as of this date. Mr. Jerome Nathans, 50 Allen Drive, Wayne, New Jersey. He is your best source for information on canvas stencils. Should you come across a stencil and judge it important evidence, photograph both the stamp and the face of the painting, send these to Mr. Nathans with a self-addressed stamped envelope and request any listings he can return to you on the history of your stencil. What you send him will increase the usefulness of his already bulging files towards solving the next problem. Eventually this data must be published, but as yet Mr. Nathans feels his listings are too incomplete. Only this past summer we discovered a Theodore Kelley stencil with a Philadelphia address; so I shall stop trying to force too early a publication.

FIG. 24. A Theodore Kelley stencil on the reverse of a nineteenth-century American painting.

Rolling a picture always makes cracks, cracks turn into cleavage—separation of the lamination—and cleavage turns into flaking, which means loss of design surface. If you must roll a canvas painting, roll it paint side out, exactly the way linoleum is rolled, otherwise both behave the same. They develop a series of multiple parallel cracks. And like linoleum only comparatively new paintings can even be rolled correctly without showing the effect of this distortion of intended plane. Any break in the picture plane, such as corner draws and ripples, has the same eventual effect as rolling.

Many people notice the irregularity of surface plane in a painting when they will fail to notice loss or other damages. These show up in reflected light when the viewer moves. Corner draws can often be eradicated by keying out the stretcher, provided of course that the fabric is strong and unbroken. Be very, very cautious about keying out to remove these irregularities. Remove the painting from its frame and check for brittle-

ness of canvas; note carefully whether the tacking edge is split free at any place; and make sure—with a raking light examination—that there is no incipient cleavage along cracks in the body of the picture. Remember, if your canvas painting is stretched on a strainer you cannot key it out. Beware of attempting to have the canvas removed to a keyable stretcher and restretched. The physical pull required for restretching rips any painting no longer flexible. To restretch without pulling the fabric taut leaves your surface with approximately as many ripples as it had before. Do not rush to a quick solution for a problem only to find the solution produces serious and expensive damage to the artifact.

Fabrics rot. There is a misbegotten notion that canvas pictures should be "fed" with oil, with patented "preservatives." Please do not do this. You can ruin your paintings, and at best you might make an immediate improvement in their appearance at the expense of an inevitable accelerated disintegration. Oil, as I pointed out when discussing the value of the size layer, darkens and rots fabric. Preservatives, which are usually based on a mixture containing balsam, catch and hold dirt, encouraging it to work down into the cracks and the cloth itself. We have few tasks more heartbreaking than attempting to preserve, let alone "restore," paintings which have been drenched with beautification solutions. Many are beyond our ability to save. These suggestions for "care" come, as a rule, from well-intended merchants and artists who have no understanding of the properties of painting structure. Artists, as I will explain to you later, know about the creation of pictures but nothing about the processes of deterioration and their prevention.

Insects will also eat fabrics, and vermin nibble bottom edges of canvasses stored in forgotten locations. Mold, neglected for a long period, actually destroys the fibers of fabric, the size serving as nutriment to the spores. Recent mold can be brushed off manually, and the area exposed to sunlight or even to an electric light bulb to dry it out. Never replace artifacts in a location where they have developed mold; it will always return to them until the environmental conditions which cause it—excess humidity and heat—are altered. Insect damage can come from silverfish, moths, beetles, white ants; their nibbling is less sizable than vermin but as clearly recognizable on the back of canvasses as it is in clothes.

Perhaps if you think of canvas paintings as you might think of clothes, it will be easier to remember the important points in preserving their fabric:

(1) environment—do not speed up the movement by exposing fabric to excessive shifts in humidity and do not leave it where mold will be born; (2) guard it from contact with water or high temperatures; (3) if a break occurs, hold the broken part together to prevent increased damage, pat surgical adhesive tape or masking tape (never Scotch tape!) gently on the reverse side to prevent distortion of plane and call your conservator; (4) never permit amateur applications on the fabric; (5) check fabric in storage for pest and fungus damage and never add an infected item to your collection until it has been cured—evil spreads.

I must add while we are still talking about canvas one other vital prohibition and explain its seriousness. I advised you to copy off information found on the back of stretchers and told you about some to be found on the back of fabrics. Unfortunately, a great deal of information is often inscribed on or attached to the reverse of canvas paintings. This habit is a very bad one with damaging results all out of proportion to their innocent cause. I have repeated—and will again—that a paint structure loses flexibility early in its life. Once it begins to embrittle, ANY pressure, however slight, can momentarily break the surface plane and give birth to hairline cracks which will in time go through the inevitable pattern of "crack, cleavage, loss." A label pasted on the back of a canvas or a mark inscribed on a back of a canvas will be reflected with a mirror image loss on the front surface, not instantly, but inevitably. I use as illustration an example on an eighteenth-century portrait of an "Unknown Lady" in the Mabel Brady Garvan Collection at Yale University Art Gallery. This example is extreme because the mark which we photographed on the reverse of this two-hundred-year-old painting was made in chalk. It seems to have been a "Q," as you can see faintly in Fig. 25, which was echoed on the front with a loss corresponding exactly to the form of this symbol, Fig. 26. Applied in the upper left corner of the reverse, note the damage which resulted in the upper right corner of the portrait, seen here lined, cleaned, with all losses filled with gesso prior to inpainting (Fig. 27). This mark was very slight, involving scant pressure, but see what it did in two centuries time. One hundred years earlier there might have been no loss, only cleavage, which could have been repaired by lining. But the point is clearly made with this example. The poor painting illustrated in Fig. 28 has a glued on paper label as well as a number "20" marked on the fabric. Major treatment was required to rectify these damages, but luckily we

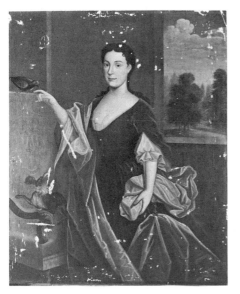

FIG. 25. (Top L.) A chalk mark in the shape of a "Q" on the reverse of an eighteenth-century canvas.

FIG. 26. (Top R.) The damage caused from this mark, echoed with loss in a mirror image on the paint surface.

FIG. 27. (Bottom L.) The painting from which the above details have been shown, lined, cleaned, with all voids filled with gesso before inpainting of losses—its "stripped-down" state. Portrait of an Unknown Lady, New York State eighteenth-century, Mabel Brady Garvan Collection, Yale University Art Gallery.

FIG. 28. (Bottom R.) The reverse of a canvas painting where a label was glued to the fabric.

caught the condition within a period of months after it occurred. Please, do not let anyone use the backs of your canvas paintings for bulletin boards!

Oil Paint

All the materials we have been discussing are underpinnings. Your picture, the design, is executed in oil paint. Since van Eyck, who was supposed to have invented it, oil paint has been a favorite media with artists. It is made by mixing ground pigments with a drying oil, usually linseed oil. The paint can be sealed in jars or tubes for storage. When it is used it may be further diluted with more oil, turpentine, benzines, kerosenes, and often with varnishes. Final appearance does not indicate what factors have been added to it, but tests with chemicals can give us clues. Oil paint can be "fat" or "lean"; fat paint has a goodly portion of medium to the amount of dry pigment contained and looks shiny; lean paint has more pigment and less medium and looks duller. Oil paint can be applied straight from the tube or jar, mixed with other colors on a palette, mixed on its support as the artist paints, put on thick, thin, in blobs, in dilute washes—it is a medium which affords the artist an almost limitless variety of performance. But it has its own restrictions.

Oil paint does not dry by evaporation; it dries by oxidation and polymerization. It combines with the oxygen in the air to form a new compound. During the first stages of oxidation, the initial drying period, there is an increase in weight and bulk. In the second stage of drying the paint gives off carbon dioxide and loses weight. Depending on the balance of oil and pigment, each of the drying stages can occur with no abnormal results. But if the balance is an improper one, as it dries the paint may wrinkle and/or rip apart. Abnormal reaction of paint films can also be occasioned by improper environments, the wrong thing at the wrong time in the wrong amount. Oxidation of oil paint can continue for as long as four hundred years. As oil paint ages it becomes harder and less soluble. The drying process is affected also by the pigments used; paints containing manganese dry quickly on top, remain fluid underneath. Thus traction cracks (see the diagram page 120) appear in areas of color with a manganese base. Consider oil paint as if it were a cement composed of pigments and oil, depending like any other cement on the qualities and characteristics of the materials combined to make it. I have no intention of

Artists' Colours (Heaton)*

Date of introduction	Inorganic Derivatives of metals		Organic Derivatives of carbon	
	In common use	Obsolete	In common use	Obsolete
Neolithic Age	Vine or lamp-black Yellow ochre Iron oxides Red oxides			
Bronze Age		Egyptian blue Malachite Orpiment		
Roman	White lead Vermilion Terre Verte		Madder lakes (Adrianople red)	Tyrian purple Kermes Woad Dragon's blood Indigo Saffron
Early Medieval XVth century XVIth century	Umber Siennas	Lapis lazuli (Persian) Verditer Naples yellow Smalt Minium (oxide of lead)	Carmine Crimson lake	Lac lake Logwood Gamboge Sap green Mummy Dragon's blood (red)
1704 1778 1781 1802 1814 1820 1829 1830 1835 1840 1856 1859 1861 1862 1870 1910 1920	Prussian blue Cobalt blue Emerald green Chrome yellow Cadmium yellow Zinc oxide Potter's pink Ultramarine Cobalt green Viridian Cobalt violet Aureolin Chromium oxide Cadmium scarlet Titanium white	King's yellow Scheele's green Turner's yellow Brilliant scarlet	Vandyke brown Sepia Alizarine lake	Bituminous charcoal (Bistre) Indian yellow Mauve lake (magenta)

* Noël Heaton, 'The Permanence of Artists' Materials', *J. Roy. Soc. Arts*, 1932, 80, 441.

FIG. 29. The time chart for usage of artist's colors, from Noel Heaton, "The Permanence of Artists' Materials."

elaborating on the chemistry of paint. I hope you will respect it as a layer full of its own activities in a company of similar prima donnas. The actual coloring matter, the pigment, has been pretty much the same down through time. I include an historical chart (Fig. 29) dating the origin of pigments as they were used by artists. Almost all the pigments to be identified in your paintings will be well known and well documented. We are a new country, not an ancient one. Folk artists had to buy their colors; they did not try to make them from scratch. What they used for diluting them is another matter, and there we run into oddities—but not in the pigments themselves.

What looks like oil paint, is oil paint, can also be water soluble. Oil and water are not miscible, they tell us. But circumstances of application, the proportion of medium to pigment, the usage of admixtures, can make certain colors in oil paint easily affected by water—so much so that they may even seem to dissolve in it. Cadmium red and yellow are often water soluble; a very lean paint on an absorbent ground may be entirely water soluble. I make this point for your protection. Plenty of oil paintings have been and are cleaned of their obscuring surface grime by washing them with water. This system is not foolproof, please be wary of it.

Remember the part of the picture hidden from view by the rabbet of the frame? I suggested you use it as a possible guide to estimate the amount of dirt or discoloration of the exposed surface. It may also show you how some colors may have altered with long exposure to light. Many an American portrait I have treated which boasts soft tones—muted rose, pale blue, pastel green—was originally brilliant in tone and bright in color. The list of pigments grouped according to their sensitivity to fading will give you an idea of which colors may have changed. We cannot bring them back. This is an irreversible chemical change.

With the advent of the "art school" in the early nineteenth century, painters ceased to continue as true craftsmen. They no longer worked their way through long apprenticeship as assistants to master painters. The old practices of grinding colors, preparing artists' materials, as part of the necessary training for the profession, was pushed into the hands of tradesmen. When the ancient period of initiate was cut short, the painter lost familiarity with the components of his art. He became even further divorced from his materials as the industrial revolution turned the

PIGMENTS, grouped roughly according to light fastness
(from a table prepared by Dr. Robert L. Feller, Mellon Institute)

1. *Pigments of good fastness to light*

Bone, Carbon, Ivory, Black (organic)
Sienna, Indian Red, English Red, Mars Red (and other Mars colors)
Umber
Naples Yellow
Phthalocyanine Blue, Green (organic)
Cobalt Blue, Cobalt Green and Violet, Cerulean Blue, Smalt
Manganese Blue, Violet
Ochre
Orpiment
Chromium Oxide Green
Green Earth
Quinacridone Reds (organic)
Cadmium Red, Orange, Yellow
Copper pigments such as Azurite, Emerald Green, Blue Verditer
Ultramarine

2. *Pigments of intermediate or sometimes variable fastness to light*

Vermilion
Van Dyke Brown (organic)
Chrome Yellow?
Prussian Blue
Alizarin (organic)
Indigo

3. *Highly fugitive organic materials*

Quercitron Lake
Cochineal or Carmine Lake
Saffron
Gamboge
Dragon's Blood
Sap Green
Persian Berries Lake
Turnsole

preparation of his materials into a commercial venture. Just because they were commercialized did not make his materials poor, on the contrary, many of them were as fine as those prepared by the most skillful of the old masters. But the painter himself was short on elementary lessons in their behavior. He forgot or never bothered to learn what went into the making of his materials, and he began to use improper mixtures or use proper ones, improperly.

During the nineteenth century a brown pigment with a bitumen content acquired vast popularity with painters. It had such a fine quality of flow, a quality which it unfortunately never loses. Like asphaltum, to which it is closely related, bitumen paint remains tacky, never drying and never settling down. There is a landscape in the laboratory collection of The Brooklyn Museum painted by Ralph Blakelock. It no longer depicts any recognizable scene. The paint films have run together and flowed over the bottom edge of the canvas down on to the frame. The surface is gummy to the touch; it always will be. Aesthetically a total loss, this Blakelock painting serves as a horrible example of the uncontrollable course of bitumen. I doubt that I have ever examined a collection of paintings without finding at least one nineteenth-century work where portions have been executed with bitumen pigment and left some dark area flowing and ripped with wide traction cracks. Excess overflow can be wiped away but the damage cannot be undone. Artists learned by sad experience and stopped using this high gloss material, but plenty of pictures are disfigured in whole or part by the nasty stuff.

Paint films crack. I have already pounded you with a goodly baker's dozen of moving reasons why they are forced to. There are very few old paint films which are uncracked. Occasionally we can enjoy a beautifully intact painting on a felicitously stable support which has escaped the customary hazards. Cracks in a once continuous layer result from movement. Movement in the paint layer, movement in the priming, the size, the support, the auxiliary support, any blow, dent, or scratch, even slight pressure, can produce a break in an embrittled film. Not in twenty-four hours or twenty-four days, but in a given period of time. A painting may look unharmed after an accident—so do some human beings—but check it over under magnification, with a raking light, with transmitted light, and if it is valued, WAIT and check again before you decide not to claim depreciation insurance. (I will tell you what this is when we deal with

insurance as a whole.) Your knowledge of structure and its anticipated behavior under factual circumstances, such as a fall, gives authority to your decision regarding monetary reimbursement. Remember you can always refer to the descriptive list of the main types of cracks in our glossary (page 118) and their visual characteristics as illustrated in the diagram (page 120) to help clarify your statement. You cannot collect insurance against age or drying cracks, but you can collect for those resulting from external causes covered in your policy. It is the difference comparable to a crease in our skin made by a wrinkle because we have grown old, and a crease left by the scar from a wound.

Varnish

The final layer to be analysed, and the first which you see, is the varnish. Varnish is colorless when it is put on a painted surface. It oxidizes with light and air to more or less intense yellows and browns. It also loses its transparency as it crazes, turns milky with bloom when it absorbs excess moisture. If it is an improper mixture it can contract to pull up the layers of the painting beneath it. Varnish is not an integral part of an original painting; it is a helpful film, supposedly replaceable, applied to prevent air-borne grime from embedding itself directly in paint and to give an evenly reflecting finish to the surface. Varnish helps us to see paintings as they were when the artist completed them; it gives any dull, dried-in tones the brilliance they had when freshly applied. Few artists ever varnish their own paintings. Varnish is an intentionally fast-drying film and must not be placed over an undried oil paint. If it were (and when it has been), traction crackle would result quite unnecessarily. Artists have always appreciated the reason for this time lapse. Order an oil painting, and the artist will tell you to have it varnished a year or so after he delivers it. I believe in earlier days that many of our itinerant painters must have given their clients similar advice. Whether these folk painters knew enough to warn against any other application than a PICTURE VARNISH we will never know for sure. Or even if they did, how available such a material might have been is a moot question. Results prove that many clients never applied any varnish (witness the amount of dirt encrusted on unvarnished paintings), and when others remembered, they too often used any surfacing coat at hand, bequeathing us a plethora of folk art coated with nut-brown floor and coach varnishes, horribly applied in streaks and drips

and practically irremoveable! None of these conditions is the fault of the original painter. He went his way, the picture he created stayed behind.

A painting is not old because it looks dark and discolored, abused and neglected. This idea is a romantic myth which has sold many a phony antique. Dirt, as my grandmother used to proclaim fiercely, is not old. Mopboards, children, and objects met with her vigorous elbow-grease in constant denial. But her discernment was sound. Age is determined by the characteristics of an object and never by its obscuring films. Faces of people as well as pictures are often improved by veils, a point of aesthetics for both. If you prefer the appearance of a portrait or a scene as it looks covered with brown or yellowed varnish, keep it that way. You need only examine your painting thoroughly to assure yourself that the varnish is working no harm, causing no cleavage—and it seldom does by itself—in the structure. Never get sidetracked in arguments over the visual appearance of a picture. The fact is that the browned surface was not present when the artist completed his painting. Whether the picture looks better with or without it is a matter of taste.

The affection for brown surface films on pictures dates from the nineteenth century when the taste-makers invented the notion of the "Old Master Glow." Maybe the preference was part and parcel of Victorian fondness for dark everything, woodwork, wallpapers, fabrics. No garish color fitted. Contributing to the somewhat surprising persistence of this fashion is the factor that early rotogravure illustrations were sepia in tone. The first widely circulated photographs of famous paintings were brown, and it became an unconsciously expected attribute for all pictures, one which seemed to increase their value in the eyes of the audience. The later part of the nineteenth century was a great period for art criticism. The power of the printed word influenced thinking, and those who were so fortunate as to travel abroad confirmed by word of mouth that the "correct" appearance of great pictures was a yellowed "patina of age." To me, the most unreasonable result of this peculiar passion was a substitution of clear varnish with a "toned" varnish on pictures which had been cleaned.

We have a series of color slides showing an unframed Corot landscape in progressive stages of cleaning. The first slide shows the scene completely browned on its exposed portions with only the edge of the picture, that hidden under the rabbet of its frame, unbrown, light and bright. As we

run the slides through the projector we show how the color changes as the varnish is gradually removed and ask our audience to compare the cleaned areas and the unoxidized rim around the edge. Finally we show the painting completely clean of the brown varnish, fresh in color, cool in tone as opposed to hot, and silvery rather than golden in its "glow." When our audience is composed of older persons they are dismayed, they felt more at home with the brown Corot. But if it is a younger group, they are delighted to discover a Corot which has subtle colors and a feeling of clear crisp air. This is a matter of conditioned taste. And I make no objection to taste so long as the truth is accepted: Corot did not paint his pictures with a brown finish. Subsequent applications of varnish made them look that way. Personally, I enjoy cleaned paintings more than I do those covered with grime and darkened varnish. To me, they are more aesthetically pleasing; they also happen to be historically more accurate documents.

In this chapter we have analyzed an oil painting from back to front. We have identified materials and studied how they act alone and together. You have seen that structure is sound only as long as it is solidly laminated, that the ingredients in each part become vulnerable as they age. I hope that you will never again think of a painting as static. I am certain you will reprove anyone you see mishandling pictures and be quite explicit regarding the damage they might bring about. Compared with its state at creation, an old picture, a desiccated picture, is tragically delicate. No one expects a bar of rust to serve the function of an iron bar. Less dramatically and far less obviously, the same is true of a painting structure which has lost its adherence. Proselytize all you can, for helpless as a new born babe and fragile as an ancient monarch, the paintings in your collection can only look to you for their care.

FOUR : *Laboratory Examination and Treatment*

W HAT happens when your painting goes to a conservator? If you went along with it you could watch every step, see all the investigations, and be there during the treatment. It might take three or four months, but there is no magic and no secrecy among any of the conservators whom we recommend. This may not be true for all those persons who claim to be restorers, but after you have finished reading this little handbook, I believe you will join in my conviction that it is true for any skilled professional of high standards, sound training and integrity.

Less than a decade ago one New York museum employed a gentleman who insisted on treating its paintings in a locked room, forbidden to any member of the staff. This procedure is as ridiculous as were medical procedures in the days when doctors delivered infants under cover of a sheet. Conservators today envy the present status of the medical profession, its schools, its funds for research, its ever increasing competence. Skill will always vary according to the individual but prerequisites can be uniform. By your understanding and your desire for quality performance, you can do more than we to help us achieve stature, even become a licensed profession; neither you nor we can afford anything but the best for our national artifacts.

Science has yet to invent the machine into which we can thrust a painting and have it come out with all the answers tabulated. We can state definitely that photographs, radiographs, and various forms of analysis do not lie, but a mistaken interpretation can make them appear to. In a laboratory examination of a painting, a conservator has a wide range of aids. Each offers valuable information under the right conditions, but interpretation of what is discovered depends on the knowledge and experience of the examiner. No technical investigation ever replaces the art scholar or the historian. Evidence revealed by a conservator may confirm, modify, or alter the opinion of a scholar. It is not a substitute for his knowledge.

Normally a painting is examined by what we call "nondestructive" methods. Those methods which we term "destructive" involve removal of infinitesimal parts of the structure for microscopic and chemical analyses; study of cross-sections such as were illustrated (Figs. 14 and 15) ; and identification of minute particles by scientific means. Very seldom would this ever be done with your paintings. It is research work. All the examination methods which we will discuss are harmless to your paintings. Ultraviolet, X ray can have deleterious effects on human beings; they have none on paintings. Normal light, raking light, transmitted light, ultraviolet, and magnification are all visible. Infrared and X ray are visible only on film. (Infrared viewing scopes exist but prohibitive cost and questionable efficacy limit their purchase by conservators.) Every form of examination mentioned can be photographed. Of all the gifts enriching our era, none has greater importance in conservation than the camera. It records our examination. It can disclose that conditions are worse than feared or better than hoped for. It is a fabulous peep show. The first thing a conservator will do after he has identified your painting, measured, and described it, is to photograph it. "Before-treatment photographs" amass everything possible to learn regarding condition, they offer a permanent reference against which to check.

There are three main considerations in approaching a conservation treatment: (1) what composes the painting, its materials and its structure? (2) what is the state and extent of deterioration? (3) what has been altered by human hands?

On a painting the extent of loss is not necessarily equivalent to the extent of restoration. In the past, and all too often today, pictures were

"repaired" and "cleaned" by ruthless processes which destroyed many of their original qualities. This technique led to elaborate repainting, often changing the entire character and form of the original. Repainting has also been applied to surfaces to falsify them for better sale. With no painting do we ever proceed blindly; we take advantage of every available scientific aid and the advice of scholars and historians wherever feasible. Such is our responsibility to the artifact and to history, and is inherent in integrity of performance.

Ultraviolet and Infrared

I have already mentioned the value of ultraviolet examination. If you were able to purchase the hand unit for yourself, you have seen the type of evidence it gives. Ultraviolet light causes fluorescence from a varnish surface of a painting which contrasts with repaints on top of varnish, some repaints underneath varnish, and other conditions which we learn to identify with experience. The information offered is limited to the uppermost layers of a picture structure. Infrared is also a limited aid; it gives us a reading of what may exist just below the surface films. If there are alterations in this strata, they may (not always) become visible under infrared. Occasionally, infrared reveals to us lightly buried signatures, either concealed by accident or on purpose. More often we find changes of design. The head of Philip IV illustrated (Fig. 30) shows a shifting of its outlines. Under infrared examination, King Philip has two heads (Fig. 31). In the final finished surface, the original drawing was ignored, and the artist chose to move the head a bit to the right. Since painters often change their schemes as they develop their design, this shift could prove that the portrait was an original Velasquez rather than a schoolpiece copy. In a copy, a surface is duplicated, not created. Naturally scholars determine authenticity on more than one point, but evidence of such change has influence on their final judgment. Had the upper films covering this alteration been denser we would not have been able to record it by use of infrared; it assists us only under very specific conditions.

X ray

Far more helpful is X ray. It shows the skeleton of a painting; everything that is present registers in varying densities. If there are two paintings on the same canvas, they both show, like a double exposure in a

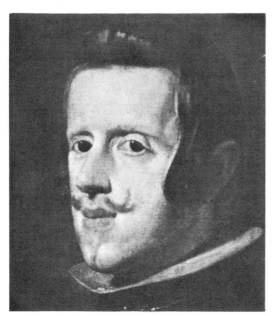 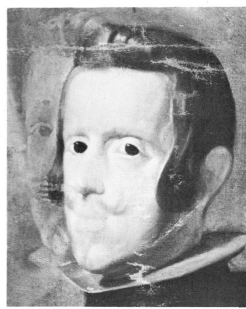

FIG. 30. (L.) **Detail from a large portrait of Philip IVth ascribed to Velasquez, shown in normal light.**

FIG. 31. (R.) **The same detail seen in infrared, showing shift in position of the head.**

film. X ray is not selective; sometimes it is a confusing jumble of upper designs with lower designs—which can be instructive too. What is shown in an X ray can be a "mirage," something which exists nowhere save in that form. For instance take this portrait (Figs. 33, 34, 35, 36) of Marie Joralemon, by an unknown artist of the nineteenth century. Her portrait before treatment showed a prim Brooklyn lady with a prayerbook and, unmistakably, wearing a pearl necklace! The lightly covered forms of the pearls seemed strangely out of place. X ray showed a different face and garment, and different accessories. Tests subsequently proved that the uppermost paint film was removable; under the dark background was a blue, light to intense, and under the black dress was a golden satin garment. The decision to remove the upper layers disclosed that the entire picture, with the single exception of the sitter's eyes, had been completely repainted. There was no doubt that we were dealing with the same person in her youth, a glamorous youth when her hair was auburn and her attire

frivolous. Very likely as her tastes and age changed, perhaps when she was widowed, she considered her earlier portrait improper and had herself repainted to a more dignified representation. The changes which are shown by the photographs of various stages in the repaint removal are fascinating, but at no point did either the first face or the second one duplicate the one seen in the radiograph (Fig. 34) because this was a composite of both faces, the younger and the older one, made by their combined densities into a third pattern of appearance.

X rays can also give us previously unknown accurate information. The Brooklyn Museum owns a portrait of "John Vinal" signed "J. M. Furness Pinx." John Mason Furness was an American painter who lived 1763–1804 and the Vinal portrait is one of his few signed works. The painting is shown (Fig. 32) along side of X rays covering its entire surface. Unlike photographs, X rays always duplicate the exact dimensions of what they

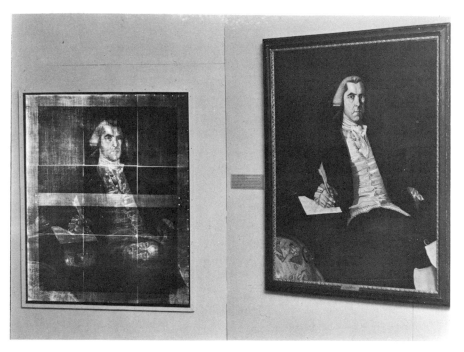

FIG. 32. Portrait of John Vinal, by John Mason Furness, oil on canvas, signed lower left, Collection of The Brooklyn Museum, shown with X rays of its entire surface, revealing the two heads sketched beneath the finished surface painting.

FIG. 33. (Top L.) Portrait of Marie Joralemon, American nineteenth-century, oil on canvas, collection of Mrs. Albert Hackett. Condition before treatment, note indication of pearl necklace beneath bow at collar.

FIG. 34. (Top R.) X ray of center portion of the above, showing different forms.

FIG. 35. (Bottom L.) Condition of Marie Joralemon portrait during removal of upper paint layer.

FIG. 36. (Bottom R.) Condition of Marie Joralemon portrait after complete removal of repaint.

FIG. 37. (L.) Portrait of a Lady, attributed to Raeburn, collection of the Norton Gallery & School of Art, West Palm Beach, Florida. Appearance of painting in normal light.

FIG. 38. (Below L.) The above, surface seen during examination with ultraviolet.

FIG. 39. (Below R.) The above, X ray of center portion showing old damages and repairs.

record. Most X-ray film used for paintings comes in 14 × 17 inch size, although for smaller pictures half-sheets or smaller film is often used to save cost. When a large painting is X-rayed completely, as in this instance, individual exposures are planned to overlap slightly so that the multiple films may be exactly joined to give the entire surface story. This is too expensive in time and money for any but unique circumstances such as the instructive exhibition which occasioned the Vinal X rays. Lying horizontally at the bottom of the X-rayed portrait of John Vinal you can see two unfinished heads. These were made by the artist before he decided to use the canvas for his finished portrait. It is not uncommon for artists to use and re-use supports but it is rare for earlier usage to register as clearly as this example, which happily adds to our knowledge of Furness' style.

The "John Vinal" painting would never be cleaned off to reveal the buried heads. We can see all we need of them as they are recorded in the radiograph. They are clearly no more than sketches, while the portrait on the surface is a finished painting. With the "Marie Joralemon" portrait, the hidden representation was judged superior to the one on the surface. Personally I do not think they were by the same artist, for the younger portrait was much more skillfully done. Without the information on the X ray it is quite unlikely that we would have her as she now is (Fig. 36). However, where X ray is really invaluable is in such a case as the "Portrait of a Lady" attributed to Raeburn (Fig. 39). It came to the laboratory because there was a small loss with incipient cleavage in the background, below the ear. Under ultraviolet (Fig. 38) the entire neck and bosom as well as other sections and outlines showed repaint. The X ray disclosed a large damage in the center of the painting: the light portions are dense white-lead filling material, the black spots are fillings made with gesso, which has no appreciable density. On the surface, as you can see (Fig. 37) the repaint matched and covered a serious loss. No removal was warranted. Without the factual evidence of the X ray we could have wasted time and money to no avail.

Few laboratories have their own X ray equipment; not even all museum laboratories have these costly machines. Any X-ray technician can make an X ray of a painting with adequate instructions for the minor adjustments needed in exposure and the major warnings required regarding the physical hazards in handling a work of art. It is fascinating to have X-ray photographs made when there are unexplained oddities in the surface of

a painting. In the process you also make friends for your collection. Many a doctor develops curiosity about pictures after discovering that they have skeletons! *

You see why we can never be content with merely one set of data. It would be too much like the seven blind men and the elephant: each described the animal from the part he held on to, but none gave the true form of the whole. Preliminary examination of a painting should determine the complete state of its structure, not just what may have happened in one layer. Materials have to be tested before any action can be taken. Each problem has its own solution, and what will work in one case will not necessarily work in another. Can water be used with safety? How easily soluble is the varnish? the overpaint? the embedded grime? Solvents and all materials used in conservation treatment must be individually suited to the character of a particular painting involved. Everything has to be planned ahead. The report of findings and proposals for treatment sent to you by your conservator is like the examination and pre-operative tests made in a hospital before surgery.

Linings

For most structural weaknesses in canvas paintings, the conservator will advise lining. To "line" means to back an original wornout fabric support with a strong new one. The two fabrics are cemented together with an adhesive which penetrates both and consolidates all the weaknesses in the original. The word "line" is used in the same sense as a "lining" in your coat, with the great difference that our linings are all-over attachment. All ancient canvas paintings have been lined, often several times over, or they would not be here for us to enjoy. Cloth has a limited life expectancy. Properly executed with suitable materials and careful performance, a lining of a painting should not have to be repeated for fifty to seventy-five years. Naturally this statement presumes a reasonable environment for the lined picture and no accidents. I have seen lined paintings which were

* In the Eastman Kodak Company's publication *Medical Radiography and Photography* (Vol. 37, No. 3, 1961), Mr. Charles Bridgman and my husband, Sheldon Keck, prepared an article instructing radiologists in the special problems they may encounter and how these may be dealt with. It would be worth your while to write Eastman Kodak and ask for a copy of this magazine (Eastman Kodak Co., 343 State Street, Rochester, N.Y.) should you have the good fortune to find access to an X-ray machine and a cooperative technician.

treated over a hundred years ago and are still in a sound state. When we remove and replace a former lining, the expression is "reline." Because language is rarely exact, you will hear the term "reline" also used when only a first lining is involved; it is always used when the treatment signifies repetition. Lining adds an extra layer, at the bottom level, to the structure of your painting.

You can see the relation of this addition in the illustrated (Fig. 40) cross-section. Detection of supporting fabrics from visual evidence is difficult. I made brief mention, in discussing the trial survey, of the possible discovery on your part of two supporting fabrics on a painting. Occasionally, when a picture is unframed you can observe two separate fabrics at the tacking edge. Other times should you find a paper tape pasted over the sides of the stretcher and lipping over the front surface of the scene, you can deduce the existence of a lining. Restorers have used gummed tapes to seal together the terminal joinings of an original and a

FIG. 40. (Below) Magnified cross-section showing a wax-lined paint structure, the relation of the added support to the old support.

FIG. 41. (L.) Detail of a portrait where the old lining has separated from the original canvas, shown in raking light to reveal the air-pockets between them.

lining fabric partly to prevent separation at this point and partly to make their job look neater. Since paper tapes have also been used to reinforce a torn tacking edge this is not an infallible test, but it is an indication of a possible lining. You might also be able to observe a marked difference between the type of fabric exposed on the reverse of a painting and the weave pattern as revealed under the painted front. This identification is more subtle, and apt to be easily apparent only to those of us with good knowledge of textiles. If a lining has been poorly executed or if it is worn out and no longer functioning, raking light examination can show shallow bubbles of apparently unbroken paint film which have no corresponding indentations on the reverse (Fig. 41). These bubbles are air pockets of separation between the original and the lining fabric. There are other telltale signs, but, as a rule, it takes a laboratory examination of a painting to prove beyond doubt the presence of a lining. Plenty of times on location surveys I have found, to my chagrin, that I failed to recognize an old lining until I had the painting under laboratory examination.

Lining Adhesives

Except where sensivity of uncommon materials in a painting requires equally uncommon means for their repair, we employ wax-resin adhesives for lining and for relining. When we reline a painting which had a glue-paste—or heaven forbid, a white lead—adhesive in its previous lining, we remove the former adhesive to the best of our ability. Wax-resin adhesive is applied in a molten state at a temperature of 135 to 150 degrees Fahrenheit; it penetrates excellently to solidify structure and to serve as a moisture barrier against changes in humidity. A thermoplastic adhesive by its very nature diminishes the dimensional movement of canvas in atmospheric cycles of dampness and aridity. The wax-resin adhesive literally flows from the new lining fabric through all ruptures in depth, permeating all permeable materials in a desiccated picture. Where it comes through cracks to the front surface, the excess is rinsed off with naphtha. Wax-resin does darken exposed, unprimed fabric, and we have to seal off such areas against excess penetration when they happen to be a part of the design, as they so often are in twentieth-century pictures. This adhesive has a long history of service. Rembrandt's famous "Night Watch" was relined with wax-resin adhesive in 1854. At the end of World War II, it was done over again, also with wax-resin, not because the

adhesive had deteriorated beyond its function but because the former lining fabric was seamed. In 1946 when this most recent treatment took place, it was possible to set looms to weave linen in a single piece to the full dimensions of the great picture.

Lining Methods

We have two methods for cementing a wax-resin lining. One is by the use of lining irons. The other is by employing an electric hot table and a vacuum pump. When lining irons are used, the painting rests face down on suitable protection. The additional support (the new lining fabric) is placed on top of the cleaned reverse of the original canvas, and the wax-resin adhesive is melted and infused throughout both the lining and the old fabric by careful manipulation of the iron. With the vacuum, hot-table method, the positions of the original and the lining fabric are reversed and the pressure applied is atmospheric. The hot table is a twentieth-century invention. It resembles a mammoth hot plate. The new fabric, the lining, saturated with wax in advance, is placed on the flat metal surface, isolated from it by a sheet of glassine or MYLAR. The painting to be lined rests on top of the waxed lining material, face up, and also protected with glassine. Strips of felt or folded linen enframe the unit, to serve as exit paths for the air (Fig. 42). Then the covering rubber membrane is laid in place with suitable securities and the vacuum pump turned on. The heat comes from the metal plate beneath the lining fabric; the pump evacuates the air between the surface of the painting and the covering rubber membrane. As the air is sucked out, the membrane conforms exactly to the surface of the picture, while the liquid wax-resin flows into every area which will receive it. The table has a thermostatic control, and for an additional check we can also use surface thermometers. The entire canvas is infused at one time and with equal heat and equal pressure. For pictures with flat surfaces the hot table is good but not essential. For textured surfaces and paintings with marked brushwork, the vacuum, hot-table method of lining precludes any possibility of crushing delicate paint forms. Under vacuum, the rubber membrane fits each hill and rill of paint surface as a glove fits your hand; with a lining iron, no matter how carefully the surface is cushioned, it is impossible to avoid imposing extra pressure on the highest points. Hot tables are expensive. Not every conservator owns one. It is the skill of the operator and not the

FIG. 42. The vacuum hot-table is a huge electric hot plate, used in conjunction with a vacuum pump (shown beneath this table on the floor), the painting to be lined rests face up on top of a wax-infused lining canvas isolated from the table with a sheet of glassine, while a second sheet of glassine isolates the face of the painting from the rubber membrane. The strips of felt covering the top of the lining stretcher help to carry off the air. The rubber membrane is stretched over the table and its hose connection attached to the nozzle end of the hose from the vacuum pump. Extent of atmosphere pressure is registered on the gauge of the vacuum pump. The heat of the metal plate is controlled thermostatically.

expense of his equipment which determines the quality of the result. I would prefer to have a painting treated by a person who is concerned with its welfare, even without a hot table, than to have it handled by someone more interested in the fee who exploits the latest equipment.

There are other lining adhesives besides wax-resin. Glue-paste mixtures are still very much in vogue with commericial firms and, unfortunately, white lead is still occasionally employed. White lead linings were contrived in good faith and great ignorance. White lead is a very permanent material and a very strong adhesive. It is also practically irremovable. In common with other forms of oil paint, as white lead ages the oil polymerizes, expands, and contracts. Used as a fairly thick joining film you can readily foresee how its action causes blister pockets, wrinkles, and distortions on the surface of what it was intended to preserve. Now and

again I have seen paintings lined with white lead which were in reasonably sound shape, but for every one of these I have seen ten which have been ruined. Future research may show us how to remove this unfortunate substance without causing additional damage to the pictures on which it has been used. Slight damage is almost inevitable, even when we are lucky enough to find a feasible removal method. Unless the painting is very rare, it is our habit to postpone any attempts to reline a white lead lining where the bond is tight. We await increased knowledge. Never, never, never let anyone use white lead to line one of your paintings.

A proper mixture of glue-paste in skilled hands can produce a sound lining bond. Glue-pastes are adhesives which only join, they do not penetrate. For those circumstances where this state is desired, we use them, subsequently sealing the exposed fabric reverse with wax. The ease and speed with which glue-paste mixtures can produce momentarily satisfactory linings explain their persistent popularity. However, the adhesive is in itself highly hygroscopic. Instead of slowing down response to absorption and release of moisture, the use of glue-pastes encourages increased motion. A strong layer of glue in a lining can act to rip a picture to pieces. Fortunately, many old linings were done with mild pastes which can be removed and replaced with wax-resin without too much difficulty. However, their removal does consume a lengthy period of painstaking labor. In all relinings, and prior to the lining of fragile surfaces, the face of a painting has to be protected during work. A broken, cupped, and cleaving picture cannot be removed from its stretcher without inviting loss. A brittle paint film which needs to have a former lining removed from its reverse is highly vulnerable. Whenever we anticipate that surface fracture could result from operative procedure, we add a lamination of our own to the front of the picture. Quite aptly this is called a protective facing. Facing tissues can be mulberry paper from Japan, gossamer chiffons, in fact any combination of delicate, sensitive materials which conform to a paint surface without impressing any characteristic of their own, and set or dry into a tight bond. Facing tissues are always tailored to surface demands and selected for the temporary function they must perform. A protective facing is a means for making a safe repair, for transporting a painting *in extremis,* for first-aid at a time of accidental rupture. It is a part of planning for subsequent treatment and not a method of cure. A protective facing will be removed as soon as the structure has been

consolidated from the bottom layers up, as it must be. It has served to hold the broken parts together from the front until their internal portions are rejoined in depth. For a physically tough relining task, we may use several layers of facings and combine various tissues and adhesives, but everything in a facing has to be thought out carefully for future ease in its removal.

The most common lining fabric is still linen, although glass fabrics and other synthetics seem to be serviceable. If a former stretcher is adequate, it may be reused. If inadequate, do NOT try to make it do. It is foolhardy to spend money on careful preservation of a paint structure and then cripple it with incorrect auxiliary support. New stretchers are made to exact measure. I happen to prefer the expansion-bolt type because they eliminate hammer accidents in keying and have extra strength in their corners, but this is personal. There are many excellent stretchers available.

The question constantly comes up: Do I approve of repairing a canvas painting by mounting it directly on a solid support such as tempered masonite? My answer is, NO, unless the painting has first been lined with fabric. Let me explain. I am not trying to make conservation work more costly, but I decline to accede to any system which, in my opinion, imperils a painting in the future. A desiccated painting is not unlike a picture puzzle—its continuity is tenuous. Suppose we reinforce the picture puzzle with a protective facing, lift it up and attach it securely with wax-resin to a sheet of tempered masonite. We have a strong solidly continuous picture puzzle which will not fall apart. Now suppose the masonite gets damaged or wears out, how do we get the picture puzzle off safely? We put on another protective facing and then work like Billy-be-damned to chip away the masonite from its reverse if glue-paste adhesive was used, or we heat the panel to the melting point of wax-resin if that was used. In either case we have no material of reasonable strength to grasp, and the back of the puzzle pieces, which are pretty fragile after all, are forced to bear the brunt of our efforts. However, had we first lined the puzzle pieces on a fabric and then mounted the fabric on masonite, even if an accident had damaged the solid support, the disjointed pieces would have a life-preserver to which to cling, and we would have a happy safety margin, a known continuous material to insure a safe removal. I believe this precaution is essential for future preservation. Every material wears out in time, and any material can suffer damage. Why not be safe?

In practice we do often mount lined canvas paintings on a solid

support. The powerful force of plastic memory induces a canvas to resume its pretreatment irregularities, even when they have been softened and forced flat. The new materials which we add can have a longer effectiveness in combating this inevitable strain if they are given the additional aid of a solid mount. We only add this support when the misshapen layer of paint and priming is especially thick or especially contorted, or when the painting is predestined for lengthy travel and needs every help we can afford it. We choose a solid mount which is stable—usually one made to individual requirements—and which offers a tacking edge of at least one inch width. A sound unit for framing is thus formed. We attach such lined paintings to these mounts with wax-resin, under vacuum on the hot table. As with any method which we employ, this procedure too has been tested to make sure that it can be undone with ease when necessary. Because of misfortunes in travel and resulting damage, I have personally undone five paintings which I had previously solid-mounted in the above fashion, and remounted them again, hoping for better futures. For alleviation of the conditions which demand such mounts, I consider the system sound, although I deplore the additional weight it adds to the picture. I disapprove of any mounting which omits the intermediate step of lining with fabric. It does not add to the cost since the mount is less expensive than a stretcher, and it only takes a bit more time. I also believe that all forms of solid mounts should have a thickness equal to the width of a tacking edge for proper security within a frame.

Repair of Supports

Each of us has a favorite method for the repair of paintings on wood, metal, and board supports. Reattachment of a loosened surface to these supports is achieved from the surface. It is always less satisfactory since it is inconceivable that every area of blind cleavage can be suspected. We cannot guarantee that we have not missed some. Customarily we infuse a solid support to solidify the painted surface rather than attempt to remove the painting. There are times when transfer is necessary for preservation, but this is an expensive procedure, time-consuming and never without risk to the picture. For wooden panels we have as yet no positive barrier against moisture penetration, but research continues. There are a variety of ways to flatten the curves and warps. The headache is to keep them flat without controlled environment. Breaks and splits we can join. I illustrate

FIG. 43. (Top L.) Reverse of a panel portrait of Washington Irving, painted by C. R. Leslie, 1820, collection of the New York Public Library, shown before removal from its frame, note nail attachments!

FIG. 44. (Top R.) Front surface of above, showing complete break in panel.

FIG. 45. (Bottom L.) Above, after treatment completed: bitumen was apparent in the paint films!

FIG. 46. (Bottom R.) Repaired reverse of above, showing button inlays.

the stages in treatment of a little wooden panel portrait of "Washington Irving" by C. R. Leslie, 1820. As you can detect from the photograph of the reverse (Fig. 43) before treatment, the break, which was complete (Fig. 44) was encouraged by pressures from the framing. It followed a line of grain in the wood. There was no appreciable loss of surface although the line of split remains even after repair (Fig. 45). We strengthened our rejoining with inlays, called "buttons" or "butterflies," just as a cabinet-maker might strengthen a break in antique furniture (Fig. 46).

There are many American paintings on cardboards, academy boards, and thin wooden panels which are in sound surface condition but a very tender state of support. They present a handling and framing problem, for any careless pressure would produce a break. For these paintings I suggest a form of temporary preservation calculated to extend them in an undamaged state for many years and yet in no way interfere with any method selected for their eventual permanent preservation. A thin but continuous support, unwarped but very breakable, may be protected and strengthened with the addition of a backing solid support, exact in dimension but completely uncemented to the original. The painting rests against the new support, is held in place and secured to it with a metal flange, the same kind of aluminum stripping which edges kitchen counters. These strips of metal overlap are cut to size, mitred at their corners, and screwed into the sides of the added support to make a unit (Fig. 47) which can be easily and safely handled and framed. It is a bit like putting an invalid into a strong wheelchair, and it is wise to remember that the invalid is still very fragile even if immediately safe and mobile. Permanent preservation of these items usually involves a reduction of their original support and an attached form of mounting, or a transfer.

Cleaning

All cleaning is hazardous. No matter how careful, how complete the preliminary examination, there are always those ghastly unexpected oddities in a paint film. All during a cleaning we check constantly with the information embodied in the photographic record. Permissible cleaning agents are determined by the character and solubility of surface accretions, but never for one moment can these be considered as separate from the paint they rest against. Cleaning is seldom a simple matter. It is the serious test of our interpretation, our judgment, and our ability. Old repaints

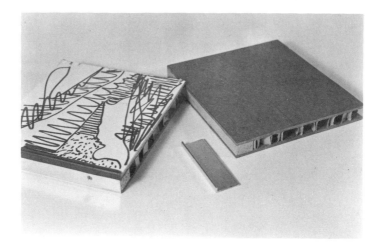

FIG. 47. These are prepared samples to show construction in cross-section. One type of solid mount we use is made from a paper honeycomb core between two sheets of thin masonite, strengthened with a narrow wooden collar—to receive our screws. A cardboard or academy board picture can be placed on such a mount, unattached to it except by the lipover molding as is shown at the left. The shiny edge of this molding can be covered with library tape or painted. This makes a firm safe unit for handling and framing.

may have been executed in media far tougher than the original paint they adjoin. When a varnish film intervenes between them and the original surface there is less danger in their removal. But when such unresponsive repaint lies directly on top of an original and more easily soluble layer it may only be possible to remove it manually under magnification, and even then not without some minute losses. Some paintings simply cannot be cleaned. At least, to date we have encountered surfaces so sensitive that no known agent can be effective in removing the films which obscure them without causing unwarranted loss. When there is any doubt as to the survival of a design layer, leave it dirty, leave it discolored. Science may find a safe method for cleaning it in the future. Wait. It is always wiser to underclean than to overclean.

Quite unjustly, the last person to work on the surface of a picture is apt to be blamed for its final state. Abrasion, damage, loss may well have been caused not only by the ravages of time but also by earlier, inept hands. Whoever uncovers these inroads bears the brunt of criticism. The uninformed have been loud in their condemnation of conservators in some of

our great museums of the world, damning them for "ruining" master-pieces. This condemnation is unfair and inaccurate. No painting of renown has escaped previous restoration. Ancient surfaces have been worked over again and again, demolished with acids, ammonia, alcohols, sandpaper, even lighted spirits of wine! Their battle scars have been heavily caked with makeup. When this camouflage is removed in the endeavor to regain the extant original, the actual remains of the artist's creation and not the craft of past restorers, inexorably the appearance of the painting is less intact. The "Mona Lisa" has no eyelashes left and very scant eyebrows; her cheeks are blanched, her lips are pale. Would you prefer her to be pencilled in, rouged, and lipsticked? Such treatment is blatant dishonesty, outrageous presumption. It perverts history. A mask of repaint can conceal tragic faults but it can never substitute for the actual face. We should not be deprived of intimate connection, however faint, with an image of the past.

Filling

Where there are complete losses in a design layer, the areas are brought up to the original surface level before inpainting. Failure to do this is a sure sign of incompetence and ignorance of the structure of a painting. Voids are filled with gesso putty which is a mixture of whiting and gelatin used since Egyptian times. At exactly this point in a conservation treatment, after the structure has been consolidated, the paint films cleaned and all voids filled, the painting should be photographed for the record. This is its "stripped-down" state, the unaffected remains of an original work of art at a given point in its life when efforts have been made to preserve it. This "stripped-down" photograph has both monetary and scholarly importance. The student can form an artistic judgment from an example of the master's handiwork which is without current modification. In this stage, its previous alterations, those from the ravages of time and man, are most clearly discernable. What has been lost, is lost, and what remains is genuine, even if ghost-like. The photograph is equally unal-loyed for an appraiser. For instance, turn back to the illustration (Fig. 27) of the "Portrait Of An Unknown Lady," American eighteenth-century, owned by Yale University Art Gallery. The one where the crayoned "Q" on the back of the canvas flaked off its echo on the front surface. The stripped-down photograph of this portrait shows extensive peppered losses

filled with gesso. There are many of these in different shapes and sizes, but if you were to amass their total, the aggregate would not amount to one-twentieth part of the whole painting. From our experience with other paintings of this type and period, we would describe this portrait as in above average state for a painting of its provenance. Extent of our inpainting, compensation for losses, can be checked by use of ultraviolet but the stripped-down photograph is the clearest and most accurate record of genuine condition you will ever have. No matter who does your conservation, please INSIST on receiving this photograph.

Inpainting

There are as many schools of inpainting as there are thought patterns of art historians and curators. Some prefer to have all loss remain obvious. Perhaps this is the most helpful state for students of art history. For the average visitor and collector, these losses are too disturbing. It is not possible to see the forest for the trees. It is hard for a person not to be distracted by what is missing from enjoyment of what is left. I prefer to have losses harmonized to blend in with design, but I am rabid on limiting all compensation to the exact amount of loss. I do not condone repaint in excess of damage, or any "improvement" in the appearance of an original paint film. This is one of the many reasons why I am convinced that creative artists should never attempt conservation. An artist cannot resist the impulse to improve even his own work. I have had the invaluable experience of working on paintings for the artists who created them. It is a privilege to check my interpretation of their intent with their verbal expression of fact. I never fail to be horrified with their lack of respect for their own handiwork, an attitude on my part which they find humorous at first and then acceptable as a compliment. Finally, we all agree that uncreative as I am, it is safer for the final appearance of their already finished paintings if I do any necessary inpainting occasioned by damage. This is the only way their pictures have any chance of retaining their original appearance!

Many people ask whether the materials which we use for compensation duplicate those used in the picture. Colors and tones, yes, but media, no. Oil paint darkens as it ages; if we were to use it for inpainting of losses in made-to-match colors, within a short period of time all our repairs would stand out in dark splotches. You may have noticed some darkened areas

on your paintings and used the ultraviolet to discover they were repaints. We try to select media which will not alter appreciably with time, which will be easily removable, and which will closely approximate the qualities of the surface it compensates. Each conservator has his special preference; many use synthetic media; colors ground in varnish are also used, as are water soluble paints. Different surface problems require the use of different media. It is customary to varnish the picture lightly in its stripped-down state so that all impainting is carried out on top of this film, isolating the original layer from our additions to it.

Varnish

For the final varnish protection most museum conservators use synthetic resins, soluble in fairly mild solvents. Their removal is simple, and they remain clear without discoloration for an amazingly long period. Varnish can be brushed on or applied by spray. Either a glossy or a dull surface can be obtained. Popular taste favors the unshiny, matte finish, but paintings with deep tones of color are more pleasantly visible with a slight gloss surface. Unless you have uncompromising convictions in regard to final appearance, let the decision as to varnish be your conservator's. He will apply what he considers best for the painting.

Framing

Security in the frame is a part of preservation. Just as it is wasteful to replace a lined painting on a miserable stretcher, it is equally uneconomic to ignore faults in reframing. Many frames are warped with age, their rabbets are not level. A framer can replace broken sections, reglue opened joints, but the average frame rarely offers a gentle resting place for its picture. Rough contact within a frame can undo a finely executed conservation treatment in no time at all. Where a frame rabbet has sufficient depth, the same metal flange used in the unattached mounting (p. 79) can serve to protect against edge damage. We screw strips of the aluminum moulding, cut to size, into the sides of the stretcher so that the one-eighth-inch lip projects over the front face of the painting. Its shine may be covered with tape or painted. This metal lip will take the beating from any rough contact and protect the tender corners of your painting. Various styles of metal mouldings have been used for stripping, as has hard wood and tempered masonite. The latter, however, involve laborious

and exact cutting. When you have observed the lines of loss dug into pic-
ture after picture by a harsh, irregular frame, it is gratifying to be able to
give so much protection by applying these bumpers. If the rabbet of a
frame is too slight to permit stripping, I would personally have it gouged
out or if necessary replace the frame.

Thick, unmounted cardboard structures and wooden panels cannot be
stripped with protective edging. Cardboard will not support screws in its
thickness and a wooden panel might be damaged by them. As I explained
in your trial survey (p. 22) for this kind of painting, the rabbet of its
frame can be cushioned with FLAN or strips of ordinary felt attached
with ELMER'S GLUE-ALL. Every attempt should be made to prevent unneces-
sary destruction.

All canvas paintings, except those mounted on solid supports, should
have their exposed reverse protected with a backing. This is the guardian
against accidents from the rear, against the accumulation of falling debris
and dirt, against the heedless application of notes and labels. Backing
boards are attached to the reverse of a stretcher with screws (Fig. 48).
They may be a clean grade of cardboard, thin masonite, FOMECOR
(Fome-Cor Corporation, 812 Monsanto Avenue, Springfield, Massa-

FIG. 48. A backing board, of good cardboard or FOMECOR attached to the reverse of a
stretcher with screws, wards off damage from accidental blows, keeps out dirt and
presents a safe surface to receive those endless labels.

chusetts) or other manufactured products which are rigid, stable, and reasonably light in weight. Protective backings are to canvas paintings what seat belts are to riders in automobiles. No loan should ever leave your door without a backing. It offers not ounces, but pounds of protection.

Not just those I advised you to purchase for our trial survey, but a vast variety of metal straps in assorted sizes and shapes are used to join paintings to their frames. Selection of the means of attachment must suit both painting and frame. But I object to frames which are held together by the pictures they enclose. I also object to the fashion of doing without frames. Unless dimension or weight makes shipment of a frame unwise, I advise you to ask your conservator to reframe your paintings rather than leaving them to an ordinary framer. Framers do not share our concern with the body of the picture. And there are those problems such as the reframing of wooden panels which demand special systems of connection which a conservator is more apt to appreciate. If you cannot have him do this for you, ask for instructions and see to it that they are carried out to the letter by whoever does the framing. Too many framers still love nails.

After the conservator's treatment has been completed, your painting will come home to you in an excellent state of preservation. With the bill for the work you will receive the full treatment report and the record photographs. You have made an investment, your painting has appreciated in value as well as in appearance. Give thought to where you rehang it. If it is humanly possible please do not hang it above the mantel of a fireplace which is used; do not hang it over a radiator or hot air vent; do not hang it in direct sunlight; and do not hang it where visitors will hit against it. I realize your problems of display may force a compromise. The painting has been through a lot. It is yours again, looking lovelier than ever, and it deserves the best environment you can give it.

FIVE : *Conservation Priorities and Procedures*

I F you have come this far with me, I am certain that you have mastered the terms we use and learned to recognize what they describe. You are in the position to make a report on the general condition of your collection which can afford a conservator sufficient basic information for estimating approximate costs on individual treatments. Before you tackle the whole job I suggest you study the sample examination form I include (p. 88) . You will see at once how the use of such a form can speed up your survey. The one I have drafted may not fit your special requirements. Eliminate the parts which do not apply to your collection, and add any categories you feel are necessary. Make up your own form, and, depending on the number of paintings you have to examine, it might be wise to have your form mimeographed in reasonable quantity. I would still use the card indexes for notes as you work. At the time you are jotting down the facts, what you jot down is more urgent than the neatness with which you go

about it. At the end of each day you can transfer—it is a good idea to type with a carbon copy—the information collected to your examination forms. Some information you might even want to transfer to your catalogue file later on. This way, when you finish the job you will have a sheaf of filled-in forms on conditions which you can sort into urgent and less urgent groups. They serve as case histories for easy reference.

Establishing Priority

In the upper right hand corner of my sample form I have placed a listing for "Priority: 1 2 3." Priority is based on a combination of physical need and evaluation of merit. For instance, a conservator making a survey of your paintings will list his priority according to physical needs, giving first priority to items in immediate peril, and second and third priorities to those paintings where treatment can be safely postponed or where only minor treatment is required. But the paintings in the worst stages of deterioration may not be those which your society considers of greatest importance in its collection. A painting in a terrible state of distress could be a copy, or a subject quite unrelated to your locality, or a poor example of some artifact of which you own better examples. Physical condition needs to be balanced against artifact value.

For you, the first priority group should include specific paintings of persons or places close to your local history. Your first priority would also include any painting of renown, whether unique in subject or the work of a famous artist. This group will consist of paintings which you cannot replace or which have a high market value. It is never easy to make these selections. That is one of the helpful parts of the examination forms. On a single sheet you have a story which presents one side of the problem, you can shuffle the sheets around so that their order presents the other point of view. All institutions are faced with this need for order of precedence. Who gets into the first lifeboat?

I feel it may help you to assign priorities if I explain how other places have come to their decisions. I have selected four different types of paintings and because by now treatment is a familiar story to you, in each case I will go into detail to describe why they were chosen immediately and what their preservation entailed in work and in subsequent value to their owners.

One of the first pictures we were asked to treat for the New York State

Sample Examination Form

Date: Name of Examiner:
Artist: Priority: 1 2 3 Accession No.
School of: Location:
Date (*circa*):
Title: Size: H W
 Shape:
Received from:

Support

—fabric	—paperboard	—stone	—lined	—cradled
—wood	—presdwood	—metal	—brittle	—hole
—paper	—glass	—other	—sagging	—tear
—academy board	—porcelain		—draws	—dent

Medium is characteristic of:

| —oil | —tempera | —mixture | —collage |
| —watercolor | —wax | —pastel | —other |

Ground and Paint film

—cleavage	—flaking	—losses
—buckling	—blistering	—scratches
—powdering off	—abraded	—other

Surface coating

—varnished	—grime	—crazed varnish
—unvarnished	—blooming	—fingermarks
—covered with glass	—scratched	—other

Framing

—framed	—held with	—no backing	—needs new screw-eyes
—unframed	nails	—poor backing	—touching glass
—broken	—properly	—screw-eyes	—separated properly
frame	secured	sound	—good backing

Results of this examination indicate:

—minor mechanical treatment —to surface —to frame —to backing
—major treatment —to structure —to support —to mount
—no treatment necessary at this time

Photograph:
 —no photograph —old photograph
 —needs to be photographed —current photograph

Comments:

Historical Association at Cooperstown, New York, was a "Peaceable King-dom" by Edward Hicks. The association owns more than one painting by Hicks. This one was not in instant peril although the artist is renowned and his work has great value. But I consider their decision to have this work done at once extraordinarily wise. The painting was an oil on canvas (Fig. 49). It was on its original stretcher; the artist had primed the canvas himself in a red ground which covered the heads of his tacks on the tacking edge: there were no empty holes (I include this statement to refresh the memory of a fellow-detective!). On the reverse (Fig. 50) was an inscription which read: "Edw Hicks To his adopted Sister Mary Leidom & her Daughters didecates this humble peice of his art of Painting," since the inscription runs on top of a patch, as you can see, this patch was obviously applied by Mr. Hicks. On the face of the painting, in the foliage above the head of the child (Fig. 51) the outlines of this patch and its entire presence is disturbing visually. Whatever adhesive Hicks used, it came through to the front of the fabric and its droplets caught the light unpleasantly. This condition was very clear under magnification. Examination with ultraviolet showed that the center portion of the scene had been lightly cleaned with vestiges of old varnish still unremoved; there were also two tiny spots of repaint in the trees and one larger repair in the left-hand border near the word "dwell." The painting, under magnification, exhibited general cupped and active cleavage (Fig. 52), but aside from minute chipped losses, (Fig. 53) it was desiccated without any serious disintegration. At this stage, the artifact was 99 per cent the work of Edward Hicks: only approximately 1 per cent of its whole showed alterations from previous restoration and the nibbling of time.

In order to remove the patch safely, we faced the surface with mulberry tissue applied with flour paste. Investigation proved that Mr. Hicks had attached his patch with varnish as an adhesive— the patch came away easily—and that he had put it on to cover up a very small puncture hole. Having recorded the inscription photographically, we proceeded to line the painting with irons using wax-resin adhesive. The lined painting was cleaned: the main portion had been, as we learned during our preliminary examination, cleaned before. It was slightly sensitive, but presented no special problems. The thick ridges of varnish where the patch had been located were removed manually under magnification. Solvent removal would have necessitated too prolonged a contact for the safety of the paint

FIG. 49. (Top L.) Peaceable Kingdom, Edward Hicks, oil on canvas, collection of the New York State Historical Association. Condition before treatment.

FIG. 50. (Top R.) Inscription on reverse of Fig. 49.

FIG. 51. (Bottom) Detail of damage on surface of Fig. 49 caused by patch on reverse.

FIG. 52. (L.) Detail of surface of Fig. 49, in raking light, showing incipient cleavage.

FIG. 53. (R.) Detail of surface of Fig. 49 showing tiny losses.

used in the tree and leaves beneath. The only complication in treatment was in the border area. Mr. Hicks was a carriage painter with a passion for lettering. The black he used was a pigment mixed with varnish, and the gold was gold leaf, over which he applied an oil varnish instead of a spirit varnish. Oil varnish does not dissolve with solvents; it can be induced to swell and gel with methyl alcohol, but its rubbery mass must then be removed with scalpels. The lettered borders on the above work (and on other similar Hicks' paintings) demand fussy delicate cleaning. It is a task to remove a tough, discolored oil film from a surface where all the black is in fast-dissolving varnish medium, and the gold is easily abraded leaf! Such cleaning can only be accomplished by vastly enlarging each section under a binocular microscope and lifting away the gelled covering films without agitating what rests beneath. Once the properties of the materials are known, all that is required is patience and skill.

The cleaned and lined painting was restretched on a new stretcher made to measure: the original stretcher was butt-end joint and off-square. The surface was given a thin spray of synthetic varnish, and the few missing areas which had been filled with gesso were inpainted. After a final varnish film, the edges were protected with taped metal stripping, the exposed reverse covered with a protective cardboard, and the painting resecured in its frame with brass straps. We made a 16mm color film of the entire treatment, not because the treatment was so unique but because the painting was in such magnificent state of preservation. It was preserved before it NEEDED RESTORATION, while it was still the statement made by its artist alone. To us, preservation is the best use of our profession. From the standpoint of art history, cultural history, aesthetics, and monetary value the picture just discussed is rare and excellent. Several years after our treatment, the association loaned "Peaceable Kingdom" to the State Department for a tour through Europe. We checked its condition before it left and when it returned: happily no accidents occurred. Countless people in foreign lands were able to enjoy a prime example of American Folk Art as will generations of future Americans. If fortune continues to smile, this painting will continue in its almost pristine state (Fig. 54). Yes, I think this was an excellent choice for a first-priority rating in conservation treatment.

My second example of wise selection comes from the Idaho Historical Society, a little painting of no artistic fame, torn and tattered. It is a local scene (Fig. 55) of "Main Street, Boise," signed "Arm. Hincelin" and dated 1864. Actually it is signed twice, one signature turned under for a tacking edge when the artist decided to diminish the size of his picture. The stretcher was a crude, homemade affair (Fig. 56), and the fabric support was a piece of cotton primed by the artist. I doubt if there were many artist's supplies available in Boise a hundred years ago. The scene is painted in colors which are mixed with varnish and easily soluble. The little picture was very, very brittle. In the course of time it had suffered a series of rip damages, and some well-meaning soul had held the torn parts together with paper tapes on the reverse. It was covered with grime and streaky yellow varnish. Infrared examination showed "squared-off" lines in pencil and outlines of all the forms also in pencil. The lines were under the paint layer, and when the artist filled in his forms he did not always follow his original lines. (I think you can see this for yourself in Fig. 57

The leopard with the harmless kid laid down.
And not one savage beast was seen to frown.

The wolf did with the lambkin dwell in peace.
His grim carnivrous nature there did cease.

The lion with the fatling on did move,
A little child was leading them in love.

When the great PENN his famous treaty made,
With indian chiefs beneath the elm-trees shade.

FIG. 54. Condition of Fig. 49 after treatment.

next to the heads of the two horses at the lower right.) To us, the squaring-off was very interesting. It is a technique usually employed to facilitate copying; but if this painting is a copy WHERE is the original? And why is it signed? We suspect, because of the squared-off lines, that Hincelin must have made more than one of these paintings on order. Were duplicates requested for more than one client? A hundred years is a long time for the safekeeping of a painting in a pioneer town that looked as this scene on its Main Street depicts. Perhaps the young lady with the parasol had a mansion outside city limits and if her house still exists it might pay to search the attic.

Aside from the obvious problem inherent in cleaning a highly sensitive paint mixed with varnish, our only headache with this picture was softening the structure in order to rejoin the rips. Using sandbag pressure

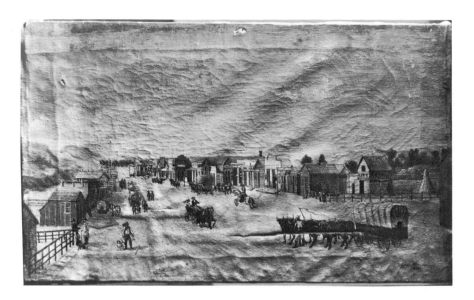

FIG. 55. (Top) Main Street, Boise, 1864, by Arm. Hincelin, oil on cotton, collection of
the Idaho Historical Society. Condition of surface before treatment.

FIG. 56. (Bottom) Reverse of above before treatment.

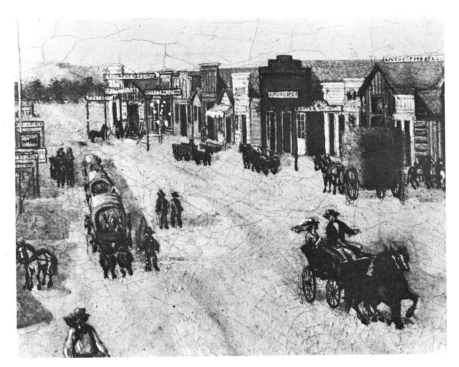

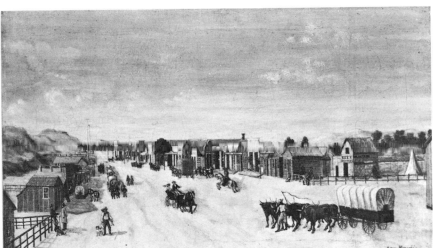

FIG. 57. (Top) Detail of Fig. 55 surface in infrared, showing pencil lines below paint.

FIG. 58. (Bottom) Condition of Fig. 55 after treatment.

and a judicious interplay of damp and dry white blotters, we were able to flatten the surface and found, to our pleasure, that most of the ruptures met neatly. The scene had suffered only slight loss. The lining was reinforced by mounting on a rigid support, for we recognized what a strong pull those old rips would present again. The small voids were filled and inpainted and the finished painting protected with taped metal lip-over edging (Fig. 58). I understand that the signs on the buildings bear names of recorded firms, but that artistic license added fanciful hills in the distance. If the other version of this scene suggested by the squared-off lines ever turns up, we might have two similar statements. Until it does, this little gem is a unique view of Main Street, Boise, 1864, and about 95 per cent the unaltered work of its artist. It is in way-above-average condition for a picture of its kind. The Idaho Historical Society may be congratulated on owning and on preserving this treasure. I consider it a priceless example of Americana.

My second example of first-priority selection was a local scene; my third is local personages. Not every village in the United States is so fortunate as Penfield, New York. They own a pair of wooden panel portraits depicting Daniel and Mary Penfield, founders of Penfield. The wooden supports were slightly warped, the surfaces were dirty, scratched and chipped, but this pair (Figs. 59 and 60) of nineteenth-century paintings were also in above average state. The panels had all the typical earmarks, from top center holes for hanging to serrated priming (specially treated to simulate the weave of fabric) under their paint films. They were "study pieces" of Americana. There were nasty layers of accretions to be removed. Long-neglected flyspecks had eaten their acid way straight through the pictures deep into the priming, and the cleaning was tedious. But the X-ray examination showed amusing sidelights. The painter who portrayed Mr. and Mrs. Penfield had no easy job of it! All through their sittings they constantly changed their minds. The traction crackle on the surface is indicative of loading fresh paint on top of undried paint and the density as recorded in the X ray is identical for both altered areas and those adjoining them. Mrs. Penfield had so many changes made in her headdress and costume that the repainting surrounds her with a visible aura of traction cracks. Mr. Penfield finally preferred a smaller shape for his head, but he ordered no adjustment in the size of his body. The X rays are not sharp, the artist was constantly reworking his surfaces, but the effect of his

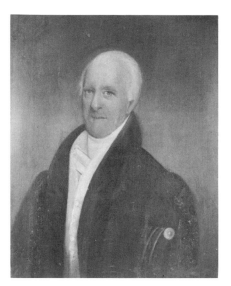 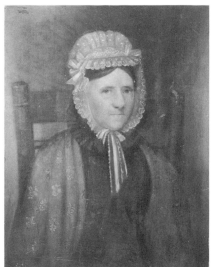

FIG. 59. (L.) Portrait of Daniel Penfield, oil on panel, American nineteenth-century, property of The Village of Penfield. Condition before treatment.

FIG. 60. (R.) Portrait of Mary Penfield, oil on panel, American nineteenth-century, property of The Village of Penfield. Condition before treatment.

changes can be seen visually once you know how to look for them. These are artifacts with intimate internal evidence, invaluable possessions for the town which bears their name. The portraits, in my opinion, were sound and intelligent choices for first priority. They establish a meaningful pattern of thought which all institutions can follow with reason.

My fourth example does not concern urgency; it concerns its opposite. Among those items which you will rightly postpone to the very last, there is always a chance of finding a hidden jewel. Less to you people than to any other group do I need to give warning that memories can be faulty, that many of us tend to perpetuate a legend without investigating its source. You deal in local history and are accustomed to weighing its fancies. When you turn your full attention to your paintings, many of their attributions will show up as wishful thinking on somebody's part. This condition is true for any collection before the chaff is weeded from the wheat. But not all surprises are unpleasant. Therefore bear with me for one more story.

FIG. 61. (L.) **Fanciful Scene by William Williams, 1772, oil on canvas, collection of The Newark Museum. Condition before identification and treatment.**

FIG. 62. (R.) **Reverse of Fig. 61 before treatment showing false attribution.**

The Newark Museum owned a painting which had come to it in a parlous state. The surface was so distorted and obscured that neither scene nor style was recognizable (Fig. 61). On the back were both an inscription and a label ascribing the work to one Sam¹ Stibs (Fig. 62), painted at "Prinston New Jersey AD 1753." No one was deeply impressed by this statement. Year after year on our annual collection inspection, this painting would be brought out of its storage slot and its condition weighed. Neither the Newark Museum nor the Kecks felt that time and cost of treatment were warranted. On one visit, however, we suggested that since the only solution to the physical state of the painting demanded a transfer and no qualification of the item was conceivable in its current form, why not send the picture to the laboratory of The Brooklyn Museum and let our apprentices learn the technique by performing it? This seemed a happy decision for all of us, including Mr. Stibs' opus.

Transfer

Transfer is a serious conservation operation. It literally signifies the transference of the design layers from a no-longer serviceable support to a new support. When a support is merely worn and weakened, we prefer to leave it in contact with the upper layers and effect a repair of structure

lamination. But when a support is an evil layer, to prolong contact accelerates decay. In transfer, the support is removed from the back of the picture; we do not, as so many people falsely imagine, attempt to peel the picture from the top like so much sunburn. Transfer is a lengthy, elaborate, and costly operation. The opportunity for demonstrating the technique to our pupils under circumstances which would actually warrant the work was welcome. For the Newark Museum here was a chance to find out what they had without expense, and for us it was a chance to train many hands in a risky performance to which we could never expose a valued item.

The painting was an oil on canvas, mounted with a thick glue onto a strongly grained wooden panel. In multiple blisters, as you can see from the photograph (Fig. 61), the fabric had pulled away from the wood as the panel had contracted violently across the grain. In addition to the separation between the canvas and panel, there was cupping and cleavage all over the surface, layers of grime and discolored varnish, and a general condition of acute deterioration. Obviously we would have to employ water in our work; therefore we needed a moisture-resistant facing. The tissue used was wet-strength paper, and the adhesive attaching it to the bubbled surface was a synthetic emulsion. Since some of the blister pockets were as high as three-eighths of an inch, the painting could not be placed face down for the removal of the wooden panel without damage. A plaster cast, strengthened with a fabric interlayer, was made of the surface conformations. In any process of relining or transference of a painting with marked surface irregularities, this step of making a plaster cast is essential to safety. When the cast was thoroughly dry, the painting was fitted into it, face down, and secured there with clamps while the wooden panel was chiselled away from its reverse. This takes time, skill and patience, but need in no way harm the picture. Once the last vestige of wood had been removed, the painting was lifted out of its cast and the canvas reverse was flattened out by moisture. Remaining specks of glue adhesive were rinsed away, and weight was used to diminish the blister pockets. The fabric was still acutely distorted: its faults were not correctable. Before the upper layers could be returned to their original plane, this malformed layer had to be taken off.

In preparation for the transfer, the facing of wet-strength paper was

infused with wax and attached with this adhesive to a white process board, a rigid material light in weight and easy to remove when it had served its purpose. The face of the picture was now firmly embedded in wax and held to the process board, but the layers were still irregular, cushioned in their irregularities by the wax adhesive. The exposed fabric was moistened and allowed to stay that way for about half an hour in order to soften and dissolve the layer of gelatin size between it and the priming. Then the canvas was gently peeled away, leaving the other layers, the varnish and dirt, paint film, and priming layer, freed from their unfortunate support. Using low heat and a spatula, we worked from the center out, section by section, persuading the vulnerable films into plane. As the heat softened the embedding wax, each part was permitted to move slightly into its proper place, and as the wax cooled again, it stayed there resting firmly against the rigid process board. Slowly and patiently all the contractions were allotted their due space, and the three layers in treatment regained their original surface dimensions. Here and there additional fractures were caused where overzealousness spatulated a fraction too soon in a not quite softened wax bed, but damage was not appreciable. At last the back of the priming layer was flat (Fig. 63), and where some of the wax had worked its way through old cracks, this surface was thoroughly rinsed with benzine and then cleaned with a mild detergent before repair. A thin addition of fresh gesso, reinforced with a sheet of silk bolting, repaired any weaknesses in this ground layer. Then the paint structure was ready for transference to its new support, which, like the original one, was fabric. We stretched the support firm and taut and attached it to the reverse of the priming with wax-resin adhesive using lining irons. (The Brooklyn Museum hot table was not acquired until several years after this transfer.) Since all the layers were now correctly bonded from their support up, the facings could be removed and the surface exposed for cleaning. The detail photograph (Fig. 64) shows the picture still on its lining stretcher. The left portion is uncovered to the picture surface, with two small test cleaning areas. Next you notice the layer of wet-strength paper facing, below this the partially removed layers of the process board which has a kernel of grey sandwiched between thin sheets of white. The process board is removed manually; the wet-strength facing which had been infused with wax is removed with benzine and xylene. Neither of these solvents had any

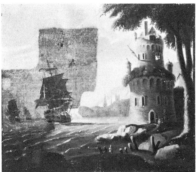

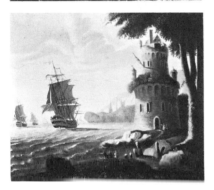

FIG. 63. (Top L.) Reverse of exposed priming layer on Fig. 61, during transfer, after the removal of the old wooden mount and the original canvas support.

FIG. 64. (Top R.) Fig. 61 after transfer to its new support, during the removal of the protective facings.

FIG. 65. (Center) Fig. 61 during cleaning, showing partial remains of dark varnish and dirt.

FIG. 66. (Bottom R.) Fig. 61, detail showing signature revealed during treatment.

FIG. 67. (Bottom L.) Fig. 61, after treatment completed.

effect on the varnish, as we knew in advance they would not. The transfer was completely successful.

The great excitement came during the cleaning. Even after transfer, no true notion of the picture was possible because there was so much dirt and such dark varnish. As one of our apprentices was wiping up vestiges of the brown gummy mess which she was removing from the paint film (Fig. 65), in the dark area between the side of the tower and the tree trunk, she noticed an inscription. Further cleaning made it legible: "W. Williams, 1772" (Fig. 66). Here was an eighteenth-century American painting, previously unknown and unrecorded, by a valued artist (Fig. 67)! What a Cinderella story! We notified the Newark Museum even before the painting was restretched. They were as amazed as we. Normally such a painting would never make a priority list. Considering its physical disability and apparent lack of aesthetic quality, it hardly warranted treatment. Perhaps we could have spotted the signature with a specially detailed scientific examination. Infrared just might have revealed it, but I am not sure. The surface before treatment was so blistered that focusing might have been too much of a problem. We could easily have examined minutely and still missed it. However, the lesson is clear. It does pay to check, even the wrecks.

After you have made your survey and have assorted the paintings into your own priority listings, how do you proceed from there? You need money. There are ways to entice gifts for conservation: an art lover; an individual who is a descendant of some painted forebear; a firm connected with some location pictured in an early scene; a bank, public-spirited and publicity conscious enough to take a chance on the importance of reconditioning a painting of local concern—any of these sources can offer you a sum sufficient to pay costs for your first treatment. Once this first step has been made your conservation program is off to a fine start. Please believe me, this is true. I have seen it happen time after time. Once they can see with their own eyes the kind of miracle good conservation can effect in enjoyable appearance, your community will begin to understand how important this undertaking is to them. Americans learn fast, they dislike half-measures, they appreciate a job well done. Properly explained, your conservation program can arouse active concern with local history.

I know one historical association where the director managed to obtain a modest sum from a member, enough to pay a colleague of ours for

treating five portraits. The portraits were of ancestors of local personages. When the paintings were returned after treatment, the director and the conservator worked out a special exhibition. They hung the newly preserved portraits in a small room by themselves. Linked to a hook at the back of each frame was a folder with the story of each treatment in simple text and with good 8″ × 10″ photographic enlargements of every interesting step in the reconditioning. In a tablecase in the center of the room, documents, letters, and memorabilia of the five persons portrayed were displayed. The local press gave the story a wide spread. The descendants and relatives were pleased and impressed. This historical association not only raised an annual budget just for conservation of its paintings, but so much peripheral attention was aroused locally, that neglected paintings came out of attic after attic as gifts.

You will never have difficulty with newspaper cooperation on a well-documented and effective conservation treatment. If the subject or the artist has local color as well, your spread will be that much bigger. You do need a touch of imagination and the patience of Job to educate your public. But once the ball starts rolling, it rolls by its own momentum. You attract gifts, you attract funds, you encourage care of paintings which may not become gifts but which should also be preserved. You serve your community in the fullest sense as a guiding force in preserving history.

Program for Daily Care

Your own work cannot stop with your survey. By now you know that paintings even in the best state of preservation are subject to constant ravages from environment and man. Even without ample funds at your disposal for creating optimum conditions for survival, many of these damaging factors can be remedied. Your next task as your five- or ten-year conservation plan gets underway is to establish your own permanent program for care.

Exhibition conditions come first, for exhibits are your front to your audience. Wherever possible move pictures away from recognized hazards such as excess light, hot or damp locations, and positions inviting accidental contact with objects or people. Umbrellas, canes, hats, and handbags are unintentional sources of trouble. A piece of nonuseable furniture (not a chair) can be arranged to provide distance between careless physical activity and a paint surface. A picture is made to be

looked at, not fondled. Fingermarks, often made in admiration, create bloom in varnish (Fig. 68) , and the viewing public is quite unconscious of its telltale harm. No painting of value to you should be hung in an entrance hall or near a coat closet. Check the lighting arrangements. If you have those individual frame lights we mentioned during the trial survey, make sure there is a protective backing to guard the reverse of the picture against pressure from electric light cords. Watch out for table lamps in proximity to picture surfaces. They may get pushed into direct contact, and the heat from their illumination can bake a surface with continued radiation. The hardest part to control will be fluctuations in humidity. You can buy one of the recording hygrometers, or an inexpensive wet and dry bulb thermometer to determine relative humidity in the different parts of your building. When the humidity is below 50 per cent, replace the lost moisture, either with a mechanical humidifier or with safely placed open pans of water. A variety of humidifiers at various price levels are now on the market. Do your best.

Where quantities of rare items are displayed, housekeeping is best accomplished by vacuum cleaners. The dirt is not stirred up to resettle on the objects. Frames of pictures should be vacuumed with the soft brush nozzle attached to the extension tube. They should not be swished off with a brush or a rag. Light, inexpensive plastic vacuum cleaners are excellent

FIG. 68. Portrait showing surface bloom encouraged by fondling hands.

for this work. Make SURE whoever does this cleaning is warned NOT to vacuum the picture part. The stiff bristles of the vacuum brush scratch and damage. The dust should always be removed from a picture surface with the wide soft brush I asked you to buy. Remember the threads from a rag can catch in a lifted corner of paint film and pull it free; besides, rags also smear the varnish with a film of grease.

At least once a month take a hand flashlight and examine the paintings in raking light as they hang on exhibition. No, you won't see all you could if they were unframed and on a work table, but you will quickly spot any marked change in plane. Note down on the mimeographed condition sheet for that painting any and all changes as you observe them. You will find these record forms prevent you from becoming upset over an evidence of deterioration that may already have been observed and noted down and shows no sign of further development. On the other hand, your gallery check can keep you posted on new damage, cupping of paint layers, even flaking, which might well alter the position of that painting on your priority list. If by misfortune you find any vandalism, I advise you to remove the picture from view promptly—even if the destruction is minor. One act of vandalism always works to invite more. A stitch in time can save both the paintings and unnecessary expenses.

Storage Facilities

What are your storage facilities and where are they located? Most storerooms are either in the basement or in the attic of a house not built as a museum. Either of these locations can be vulnerable to water leakage, pipe breakage, excess dampness, and excess aridity. They are also as a rule lacking in physical security and replete with air-borne dirt. As you rarely have much choice, if these locations are your only storage spaces, do the best you can to improve them. First of all try to keep everything stored OFF THE FLOOR LEVEL. Three inches helps in case of a flood, even one inch and a half is better than nothing. I have seen fluke inundations in places where they have no business existing. This off-the-floor preparation can save an entire group of artifacts from serious destruction. When water has invaded a premise, everything has to be taken out and the place dried out before objects are returned. Most accidents of this type have a nasty habit of taking place when nobody is around, and long hours may pass before remedial measures can be taken. Fire is beyond doubt the most devastat-

ing of all scourges, but water comes a close second. Your best instruction on fire prevention will come from your firehouse personnel. If they have not given you their advice, ask for it. Ask your insurance agent as well. Be sure these people are aware of your problems and that you are familiar with the regulations which govern their procedures. I have included a sheet on suitable fire extinguisher units in the appendix; your local people can help you place these units. All of them will warn you against litter. Old boxes, old papers, cartons, rags and oddments do not belong in safe storage space.

The basic considerations for storage of artifacts are physical security and easy accessibility. You may stack a few paintings safely on your padded blocks leaning them against a bare wall while you are working with them, but this is not a permanently secure system of storage nor is it an efficient use of space. Ideally, paintings are best stored on sliding screens. Both sides of a well-constructed screen can carry pictures to their full dimension of height and width. The amount of space required for screen installation is exactly twice the dimension of the screens. Although the tracks on which the screens move must extend this full distance, the screens themselves when not in use are slid to a common side permitting free passage across their tracks at all times. All-metal storage screens may be purchased. They are expensive. Less elaborate but good sliding screen storage can be constructed with heavy mesh (Figs. 69, 70) and wooden frames. Those which I illustrate were constructed by the master carpenter at the New York State Historical Association in Cooperstown, and their total cost was under $1,200. You can see their advantage in economy of space and ease of viewing. A picture in such storage can be seen with no more trouble than a pulling out of the screen which carries it. Neither the picture in demand nor any other pictures need to be shifted about during the examination.

If you do not see your way to the construction of storage screens, construct a series of wooden or metal slots in varying widths and heights into which you can slide your paintings, being sure to separate the items with rigid interleaves of strong cardboard, masonite or homosote. Many museums use this type of storage, identifying the contents of each slot division to facilitate search for a special item. I illustrate (Fig. 71, 72, 73) an extraordinarily well-planned storage vault developed at Hartwick College, Oneonta, New York. The retail cost of the equipment and

FIG. 69. (L.) View of storage racks in Fenimore House, New York State Historical Association, screens, here shown all slid to one side, when not in use.

FIG. 70. (Below L.) Same screens, being used, note screening carries paintings on both sides.

FIG. 71. (Below R.) View of one section of storage bins constructed at Hartwick College, Oneonta, for their art vault.

FIG. 72. (Top) Another view of the vault, showing variety of bin size and excellent amount of space for handling.

FIG. 73. (Bottom) Another view of same vault showing placement of atmospheric control units, careful treatment of pipe, and prepared examination table—including pair of padded blocks in view!

materials—an Armstrong HUMID-I-MAKER; a heat control unit from Heat Controller, Inc., Jackson, Michigan; and a Nutone Fan—came to $1,215.00, not including the labor of installation. The college's own maintenance men installed the equipment and built the stalls which house the pictures. The carpet on the bottom of each stall came from rug samples donated by a local flooring center. The fan is installed in a window and wired to special controls designed to change the air in the room four times each day in equally divided periods. I have surveyed paintings in this storage space and am filled with admiration for the neat and practical system. They have no difficulty in locating any item with dispatch. Good light and examination space is well arranged. The card index identifies each painting in its particular slot. I have rarely seen a small storage vault more intelligently conceived, even to atmospheric controls. The college was very fortunate to have a fine, tight room which they could allocate for this purpose, but common sense and wise planning made excellent use of it.

Remember, handling and dirt are problems. Both storage bins and sliding screens are best placed in areas shielded from air-borne dirt and human traffic. As in any other kind of packing, an orderly system holds more items and keeps them in better condition. Humidity can be controlled automatically. Good storage only seems a luxury when you do not have it. Initial costs are not an extravagance in retrospect. If you can make one step in the right direction each year, this program too will reach fulfillment before you know it.

There is an unfortunate difference in the viewpoint between the way we think of artifacts which are enjoyed and objects which are used. Automobiles we have serviced, repaired, kept in running condition. Clothes we have cleaned, mended, and moth-proofed. We know, from experience, that such items wear out, and we take precautions to make them last as long as possible. Artifacts do not belong in the category of use, but they are subject to constant forces of deterioration, which, if ignored, work their destruction to the vanishing point. Why should artifacts arbitrarily be placed in a compartment outside the normal current of common sense? To me, they should be in the forefront of our attention because, unlike automobiles and clothes, art is seldom replaceable.

Insurance Coverage

Accidents happen. We try to prevent them, but they do happen just the

same. Try to enforce the notion that an accident is not necessarily anyone's fault but that it is always a fault not to report it. If one of your paintings has a misfortune, notify your conservator immediately and follow his instruction on whatever first aid he recommends. If you have insurance, notify your insurance company. Fine arts insurance is an enigma to many people, unfortunately also to many of the agents who sell it. I have tried, so far in vain, to get insurance companies to publish a handbook explaining the various kinds and the protection of fine arts policies they offer. As it now stands, the man who might sell you a fine arts all-risk policy is unlikely to be the man who adjusts any claim for damage. Claims seem to be handled from a legal standpoint, and their settlement depends to a great extent on the reputations of the claimant and of his agents. Few small museums or historic houses can afford to insure their entire collections. More valuable items are apt to be covered against theft and accident, and any item loaned or borrowed is also protected by insurance. You can buy a policy for just about any amount you elect to ascribe to an item, but if it gets lost, stolen, or damaged the insurance adjustor will insist on an acceptable valuation made by an acceptable person before any settlement of claim. Since this is the way insurance works, I suggest you get an acceptable valuation and record it as such with your agent BEFORE you pay premiums on a policy. Do not pay just anyone for an appraisal; make sure in advance that valuations are jointly satisfactory. If you fail to do this, do not blame your insurance agent if despite a full premium payment you find yourself holding the bag on an unsettled claim. Accurate appraisal is based on close knowledge of the art market, although special considerations can influence final evaluation. Much of your material falls under this last division. For instance, a painting which would bring no high price in a Manhattan auction room, could be, for reasons of local history, of great value to your collection. The valuation figure reached is determined by the purpose of the appraisal—selling, replacement, special sentiment—the last mentioned two being your main issues. Whatever appraisals you accept for insurance of your treasures, make sure that they are satisfactory to your insurance company. Get this assurance from them in writing, with a legible signature. You will be dealing with lawyers if there is a serious claim. Insurance companies have much information which is not always familiar to their distant agents. Ask for fire ratings on your building; find out what

policy forms might ease your premium burden. You can tailor your policy to fit your needs if you can reach the right person in a company. Read the small print and make sure it fits your needs. Insurance companies are very obliging when you force their attention.*

Appraisals

Conservators do not appraise (buying and selling of art is not our business), but they render assistance on occasion of damage by reporting extent, cost of repair, and in giving their opinion as to the proportion of depreciation suffered. This evaluation will come as a percentage, not a numerical figure. A torn painting can be repaired, and the skill with which repair is accomplished is an important issue, but no artifact once damaged has the same value it had in its undamaged state. When an insured item has met with an accident, your claim should cover both the cost of its return to exhibitable state and the amount of depreciation in value. I am going into detail on this subject for a reason. Optimum repair for a tear in a canvas painting is to have it lined, but a tear may also be repaired with patching. A patched painting may be displayed; it will last structurally. However, the terminal outlines of the patch inevitably become visible with the passage of time (Figs. 74, 75); the difference in layer thickness, stress and strain from the adhesive, eventually makes itself apparent in relation to the remainder of the picture plane. With a serious rupture, I doubt that your insurance adjustor would give you much argument. But with a small rip he might hold that his company's responsibility was met by the cost of patching, that lining was in excess of adequate restitution. Should you also claim, with complete justification, depreciation in value due to the damage, the adjustor may find it to his advantage to settle for payment of a full lining on abrogation of your depreciation claim. The company pays less in the long run, and you get an optimum repair. Since presumably your paintings are not for sale, the above is a wiser decision on your part for the welfare of your collection, and you are merely exploring the full extent of your rights. All your

* If your agent would like assistance in working out a policy for you, suggest that he ask The Aetna Insurance Company, Hartford, Connecticut, for a copy of their Fine Arts Insurance, Museum Form. This form was developed over a period of years by a staunch friend of the arts, Mr. John Lawton, an insurance underwriter of vast wisdom and sympathy.

FIG. 74. (L.) Detail of a fabric reverse showing a patch applied to mend a rupture, this has carefully frayed edges to minimize its outlines.

FIG. 75. (R.) Front surface of exactly same area shown in raking light to exaggerate the inevitable impression caused by the applied patch.

insurance contacts will be greatly facilitated by complete photographic records. Such records place you in an invulnerable position regarding your claim to prior state of a damaged item.

Photographic Records

You already know how I value photography. Surely you have some member of your group endowed with this skill. Explain physical evidence in a painting as you have learned to observe it, and a good photographer will be able to record it for you after a short trial period. Photography of paintings requires a special knack, but I have never encountered an expert photographer, sufficiently interested, who could not master the technique. It is a matter of lighting. Show him how your picture changes between normal light and raking light, make him see what you see and let him figure out how to get it down in black and white. Color is lovely, but record photographs in black and white will serve your needs best. One word of warning: stay with him while he photographs and handle the painting yourself. Museums learned this by bitter experience. The photog-

rapher is thinking about his camera, his lights, his exposure; you have to think about the painting. My husband, who once accompanied a famous loan collection overseas, almost came to blows with photographers until his regulations for the safety of the paintings during their photography were backed up by the United States Embassy.

Even if you can not arrange to have every painting in your collection recorded photographically, I beg you not to lend any item without this irrefutable statement of its condition prior to loan. Paintings today are peripatetic. I will never forget the priceless newspaper account of the time when Whistler's "Mother" passed the "Mona Lisa" on the New Jersey turnpike! I am in favor of more and more people having the opportunity to see original rarities, but sad experience has taught me how expensive travel can be for art. All that handling, all that motion, all those environmental changes take a big toll. Common sense dictates precaution in advance—and irrefutable records.

Packing for Shipment

Possibly your historic house does not lend, but if you do, shipping is another part of your responsibilities in conservation. Incidentally, the borrower is supposed to pay insurance fees, shipping fees, and costs for crating. Settle these details well in advance and have them down in black and white. Telephone conversations between friends are all very well, but when catastrophe strikes, a letter makes subsequent procedures uncomplicated. Refuse all loans of paintings which are not structurally sound. For your own and the painting's future security, date and fill out an examination form recording the exact physical condition of the artifact immediately prior to shipment. Check carefully the attachment of the frame and the soundness of the protective backing. Remove hanging wires. The framed painting should be wrapped in glassine and the wrapping tightly sealed against penetration from packing materials. (As you may have learned, glassine is NOT waterproof!) Optimum packing has the glassine-covered item further protected inside a cardboard carton. All this careful packing takes time and material as well as the knack of fitting cardboards to a special shape. I have "boxed in" many a framed painting and would never underestimate the struggle of adjustment. Please take note of the dangers to be controlled—forgotten nails, tacks, splintered sections of wood, and especially staples. Corner pads to cushion carved parts of a

frame are usually attached with staples to the flat portions at the back of a frame. This procedure is sound, a staple gun offers the slightest form of shock. However, staples work their way free, and a loose staple inside a crate shifts with every motion and can scratch and puncture, even plow furrows across a picture surface. A minimum amount of extra time and cost is required to cover the staples with strips of masking tape. Even if they work free, the staples are caught and held in the tapes. Excelsior is also a nuisance; even the paper enclosed pads break open and scatter their sharp bits indiscriminately. The glassine wrapping will protect a surface so long as the glassine remains unpunctured. Superior packing materials are crepe paper, used by most liquor firms, and the synthetic foam materials. Perhaps you can ask a store to save some of these items for your use; but store them away from fire hazards! The crate for shipment, depending on the number of items included, their size and weight, should be made around a strong wooden collar with sides of either tongue-in-groove boards, masonite or plywood. Up to the final closing, nails can be used in the construction. The lid, after the contents are in place, should always be attached with screws to obviate hammer blows and facilitate unpacking and easy reuse of the crate. The inner face of the crate should be lined with strong waterproof paper, stapled in place (staples covered!) and planned for excess to envelop the contents completely.* The principle of good packing is to float the objects inside a case planned to house them safely and to ward off any transmitted shocks or penetration of fluids. Rain and snow we expect, but it is even possible that adjacent shipments in a carrier's van can leak or even ferment out and over your case during transit. Stipulate in your loan agreement how your crate must be packed (screw-top again) on its return to you and via what carrier and under what terms.

To make a case too heavy or too large invites mishandling. Even on reasonably sized crates, apply hand-holds to their flat sides to make the unit easier to pick up and carry. This does not preclude a "dumping out" of your crate, but at least it makes it less likely to be turned end over end by a trucker. No matter how many red letters proclaim a contents

* I advise you to send to the Metropolitan Museum for their 25¢ booklet on *Paintings, Packing Instructions for Supervisors, for Packers,* written by Robert Sugden. Read it yourself and insist that any local packer follow its instructions. You may have an argument to make him agree, but once he has done the packing properly he will take pride in his new ability as an art packer.

FRAGILE, I have yet to meet a truckman willing to be a proper nursemaid. Use regular shipping contracts and insure contents for the currently permitted value at that rate. For REA the rate is $550 per shipment maximum coverage. Their special Fine Arts Contract is very expensive and offers no additional protection worthy of its cost. Insure with your agent on the Fine Arts All-Risk Policy and let him fight the carrier in case of transit damage. He is much better equipped to handle the problems than you are. No matter how many precautions you take, and please take all of them, risk is a part of every trip.

My husband, Sheldon Keck, instigated a system of protection against unauthorized dismantling of a painting. It is hard to understand why, but many borrowers unframe paintings for one reason or another. They usually fail to admit to this, and many unnecessary damages can result. Also on any item covered with glass, careless handling breaks the glass, and it may be replaced by the borrower without being reported to you. Mr. Keck had a small label printed (you could write these out in longhand on a gummed label) which read: "Do not remove this painting from its frame without obtaining permission from The Brooklyn Museum." He had one of these labels attached with ELMER'S GLUE-ALL (this glue cannot be dissolved without destroying the label) over the screw-end of a metal framing strap. It makes unframing a physical impossibility without breaking the little label. This idea can be an excellent safeguard and serves to surprise the borrower into fresh respect for an evidently well-cared-for item. And it does stop unauthorized activities with your painting.

An atmosphere of competence is impressive. It adds distinction to your exhibits, increases admiration from your audience, and it invites gifts. The Brooklyn Museum was once notified, out of the blue, by a wealthy collector that he wanted their curator to visit his home and select two paintings from his collection as gifts from him to the museum. He was not a member of the museum; he did not even live in Brooklyn. He explained that as a chance visitor to the museum he had been so gratified with the excellent condition of the paintings exhibited that he decided some of his possessions should become recipients of this same care. The little extra attentions, the housekeeping routines which we have discussed, will help to make your historic house an ideal home for the treasures of others. Perpetual care is a comforting thought. The habit is neither hard to

acquire nor too onerous to maintain. The results are very rewarding. I find myself mentally and emotionally offended when I see paintings neglected. Conversely, I enjoy them most when they are in fine state. I believe, even if only subconsciously, everyone reacts this way.

The whole concept of art conservation as I have related it to you is fairly recent. Years ago to restore meant to repaint, and the work was assigned to inept artists who earned a pittance from their miserable craft. The wonderful advances of science have shown us how to study paintings in depth, how to understand their nature and their requirements. None of us has a real excuse for neglect; we know better and we know what neglect costs us. All of us are faced with constant demands for our energy, our time, and our money. The claims on our sympathies are without end. Everywhere cultural wonders are deteriorating with frightening speed. But much as I am disturbed by the waters of the Nile rising to engulf the monuments of Egypt, I find myself increasingly aware of the need for us to cultivate our own garden. If we disregard what we have, who will come to its rescue? Ours is perhaps a comparatively slight treasure judged by standards of world masterpieces, but it is native and as such unique in period and place. If we preserve well and with honesty we need not apologize, for your collections are the attributes of our culture. They are American history.

ᴈ *Appendix*

GLOSSARY OF TERMS

Blister—An inflated pocket in a film or in a layer, produced when either has been made plastic by heat, solvent action, or both. A separation between layers which has bubbled up.

Bloom—The bluish white cloudiness often seen on varnish surfaces. When it occurs on an unvarnished surface it is called Blanching.

Buckling—A distortion of the picture plane often accompanied by a rupture in a paint or ground layer, caused by shrinkage or compression.

Check—A break in wood, running along the grain, an incomplete split.

Cleavage —Any separation between or in any of the laminated layers of a painting. It is a loss of adhesion. *Active cleavage*—A separation which is about to flake off. *Blind cleavage*—A separation (like buckling) also called *Flat cleavage,* which has no visible rupture. *Incipient cleavage*— The beginning of a separation, layers curled up but not yet quite free.

Compensation—Replacement of loss, usually applied to loss in the design layer.

Cracking—(see diagrams) A pattern of fracture lines caused by movement either of the films or of the layers adjacent to them. *Age cracking* —Fracture lines due to desiccation, usually penetrating all layers to the final support. *Drying cracking*—(also called Traction) Resembles alligator patterns or the surface of an orange peel. They are caused by the application of a quickly drying layer over a slower drying layer. They can occur in the paint films, the varnish, even in the ground. Their intervals are wide. *Mechanical cracking*—Fracture lines which result from a blow or dent and usually assume a cobweb-like pattern, or those resulting from a scratch or rub which have feather lines. These are both accompanied as a rule by a distortion of the picture plane visible in raking light.

Crazing—A very fine system of cracking in a varnish or paint film which appears slightly opaque to the eye. It is found in aged films which are very dry and are approaching their final stages of embrittlement. It can powder off.

118

Curling or Cupping—Paint, or more layers of structure, which are islands with their edges lifted and raised away from each other or from lower layers. Strong cupping of cracking paint structure can distort a support.

Draw—Wrinkles or ripples which radiate from edges and corners of paintings on fabric.

Flaking—The loss of sections from one or more layers of a painting above its support.

Grime—Dirt of any kind, on top of paint, on top of varnish, buried under varnish.

Key—The triangular wooden wedge employed in the slot at the inner joint of a stretcher to enlarge its outer dimension mechanically.

Loss—A missing area in one or more layers (even all) of a painting.

Moisture barrier—Any material of low moisture permeability applied to an object to retard the transfer of moisture to or from it.

Rabbet—The inner groove behind a frame opening, planned to receive the painting.

Strainer—An auxiliary support of wood over which fabric is attached which is fastened tight at all joints.

Stretcher—An auxiliary support of wood over which fabric is attached which is tongued and slotted at its joints to permit dimensional enlargement.

Tucking edge—That part at the extremities of a fabric used for a painting which is planned to be turned over the sides of its auxiliary support and serve as a means of attachment.

Void—A loss in painting structure, usually applied to a loss in all the layers above the support. It must be filled to surface level before inpainting.

DIAGRAMS EXPLAINING SOME VARIETIES OF STRUCTURAL DETERIORATION IN PAINTINGS

Top layer = varnish *3rd layer = ground*
2nd layer = paint films *4th layer = support*

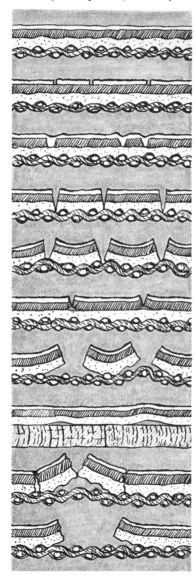

Fresh varnish on a new oil painting on fabric

Cracking in the varnish layer only

Drying (or Traction) cracking in the paint layer with varnish applied after cracking has occurred

Age (also mechanical) cracks penetrating varnish layer, paint film layer, and ground.

Cupping (or curling) of varnish, paint, and ground, pulling up canvas to conform to cracks.

Cleavage between paint and ground, occurs at cracks but is only interlayer here. Ground is still continuous. Incipient cleavage.

Cleavage between ground and support. Cupped islands of varnish, paint and ground are lifted away from their support. Active cleavage.

Blind (or flat) cleavage between ground and support—diagrammed in a wooden panel—barely noticeable on surface. Can also occur between layers in a canvas painting, or between a lining and an original fabric.
Buckling of paint and ground away from canvas support due to shrinkage of support.

Flaking of structure to the support, a loss of varnish, paint and ground, with cleavage on either side of loss as is common

120

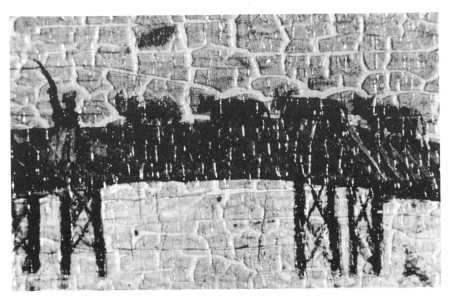

FIG. 76. (Top) Detail of a painting covered with a discolored varnish which shows marked traction cracking.

FIG. 77. (Bottom) The exact same area with the cracked varnish removed, proving that damage sometimes occurs in one layer of structure without altering what it covers.

FIG. 78. Age cracking in a desiccated canvas painting.

FIG. 79. Mechanical cracking in the same painting, note marked cob-web pattern of fracture lines denoting blow at its epicenter.

FIG. 80. Detail of a canvas painting showing strong traction cracking of the paint films limited by the nature of their materials to certain areas of the design—there are none in the legs!—nor are the cracks continued into the edge of the painting where it was hidden from light and air by the rabbet of the frame. A fine example of all the causes of deterioration we have discussed, behavior of materials and effect of atmosphere on artifacts.

FIG. 81. (Top) The reverse of the Sully portrait #9, showing an old patch over a repair, and the way cupped paint can pull out of plane its supporting fabric, along the lines of the cracks, into a quilted appearance.

FIG. 82. (Bottom) Detail of a portrait showing tiny voids due to long-neglected mold which so weakened the structure that these bits of the upper layers powdered off.

SOURCES OF SUPPLY

ANDREW TECHNICAL SUPPLY, 1824 West Kenzie Street, Chicago 2, Illinois. For 25¢ you can buy cardboard humidity indicators, not exact but helpful.

BAINBRIDGE'S, Chas. T., Sons, 12–26 Cumberland Street, Brooklyn, N.Y. All rag museum mat board. Ask for their price list.

BAUSCH & LOMB, Inc., Rochester 2, New York.
Inexpensive magnifiers of all types. Folder on request.

BLOCK, Huntington T., 1025 Vermont Avenue, N.W., Washington, D.C.
Specialist in Fine Arts insurance. Reliable advice.

CLEVELAND–BURTON COMPANY, 7922 Haskell Avenue, Van Nuys, California 91406. This firm makes an excellent Illuminator #1931 4T, which has a magnifier combined with both white and ultraviolet light in a hand unit which plugs into any electric outlet, cost about $56.00 and well worth it.

FOME–COR Corporation is a division of Monsanto Company. The material is available from their distributors who will also supply you with data sheets on types, sizes and price range. Herewith three distributors in various sections of the USA.

Fome–Bords Company, Suite 201, 55 East Washington Street, Chicago, Illinois
Henry Fuchs and Son, Inc., 94–104 Ninth Street, Brooklyn, New York
Sidney Newhoff and Associates, 1200 So. Figuera St., Los Angeles, California

FOREST CITY PRODUCTS, Inc., 722 Bolivar Road, Cleveland 15, Ohio.
These people make FLAN, and can tell you where to get it locally.

INTERNATIONAL FILM BUREAU, Chicago, Illinois.
This firm has available for rental a 25-minute 16mm black & white film with sound track which we made on a conservation treatment. It is called "A Future for the Past" and would help arouse local interest.

LEBRON, James J., 57–19 32nd Avenue, Woodside, New York 11377.
Originator of the expansion-bolt stretchers. Cabinet-maker to the fine arts, work-tables, storage racks, etc. Inquiries welcomed.

ROSENTHAL, Philip, & Co., 840 Broadway, New York, N.Y.
Soft brush for cleaning dust off pictures, glassine paper, etc.

SCULPTURE ASSOCIATES, 101 St. Mark's Place, New York 9, N.Y.
Unique hand tools, spatulas, cutting utensils. Catalogue on request.

SEARS ROEBUCK & CO., any store or mail-order catalogue.
MYLAR in 3 mil thickness and varied widths, fine stock of inexpensive humidifiers and dehumidifiers.

STERLING MOVIES USA, Inc., 43 West 61st Street, New York, N.Y. 10023.
Available free is a film I made called "The Hidden Life of a Painting," 15 minutes, black and white with sound, 16mm size. It is the property of The Continental Insurance Company.

STROBLITE COMPANY, 75 West 45th Street, New York 36, N.Y.
Portable ultraviolet hand units. Data sheet on request.

TENSOR ELECTRIC DEVELOPMENT CO., Inc., 1873 Eastern Parkway, Brooklyn 33, N.Y.
If you cannot buy a "foldaway" unit locally ask here. Units cost from $17.50–$72.50 and are excellent examining lights.

ULTRA-VIOLET PRODUCTS, Inc., 5114 Walnut Grove Avenue, San Gabriel, California.
All types of ultraviolet lamps. Catalogue on request.

THE FRICK ART REFERENCE LIBRARY, 10 East 71st Street, New York, N.Y. 10021 Mrs. Henry W. Howell, Jr., Head Librarian

If you are not familiar with this remarkable institution you should be. It houses the largest collection of photographic records of paintings in this country. Anyone wishing to do research is welcomed to use their facilities. Because of their small and extremely busy staff, they can only answer questions of limited scope by mail, but if the answer is at hand, they will supply it.

The Frick Art Reference Library is interested in receiving photographs of documented paintings, painted before 1860. Portraits, still life, landscapes, historical and religious paintings and drawings prior to 1860— all concern them. If you will send negatives to the Frick, they will make prints for their files, and return the negatives to you. I reproduce the form which they ask to be filled in; this data is filed with the photograph of the painting.

I suggest that if you think any of your material could enrich their files, that you take the trouble to send it to them along with the correct information. If you do this, you are in a position to ask favors from them, should you come across an important item which is a mystery to you. Please do not abuse the Frick, they are too hard-working and valuable, but a respectful use of their vast knowledge can be a godsend to you when all else fails.

ARTIST: DATE OF WORK OF ART:

SUBJECT:

DATES OF SITTER (IF PORTRAIT):

GENEALOGICAL NOTES:

MEDIUM (PLEASE CHECK OR WRITE IN):

OIL ON CANVAS OIL ON PANEL (WOOD, ACADEMY BOARD)

WATERCOLOR DRAWING (PASTEL, CRAYON, PENCIL, CHARCOAL,

PEN & INK, PEN & WASH) MINIATURE ON IVORY MINIATURE ON

PAPER SCULPTURE

SIZE (SIGHT OR STRETCHER MEASUREMENTS):

COLOR NOTES:

PRESENT OWNER (RELATIONSHIP TO SITTER, IF PORTRAIT):

ADDRESS:

PREVIOUS OWNERS:

EXHIBITIONS:

PHOTOGRAPHER:

ADDRESS:

REPRODUCTIONS IN PUBLICATIONS:

SIGNATURE OF OWNER OR PERSON SUPPLYING INFORMATION:

DATE:

SOURCES OF FURTHER INFORMATION

Bridgman, Charles, and Sheldon Keck, "The Radiography of Paintings," *Medical Radiography and Photography*, Vol. 37, no. 3 (1961). Rochester, New York: Eastman Kodak Company. (Instructions for medical personnel.)

Dudley, Dorothy, and Irma Bezold. *Museum Registration Methods*. Washington, D.C.: American Association of Museums, 1958. (Excellent information.)

Frankenstein, Alfred, "Finding Names for Nameless Artists," *New York History, the Quarterly Journal of the New York State Historical Association* (April, 1959). (Wonderful suggestions.)

Graham, F. D. *Audel's House Heating Guide; Including Ventilating and Air Conditioning*. New York: Audel Publishing Company, 1948. (Good suggestions. Order from Audel Publishing Company, 49 West 23rd Street, New York, New York. $4.00.)

Held, Julius, "Alteration and Mutilation of Works of Art," *The South Atlantic Quarterly*, Vol. LXII, no. 1 (Winter, 1963), 1–27. (Well worth sending for, from Duke University Library, Durham, North Carolina. $1.00.)

IIC Abstracts. Semiannual. London: International Institute for the Conservation of Historic and Artistic Works. (Write for information on membership or purchase of publications, in care of The National Gallery, Trafalgar Square, London W. C. 2, England.)

Infrared and Ultraviolet Photography. (Kodak Advanced Data Book No. M-3.) Rochester, New York: Eastman Kodak Company, 1963. (For your photographer. $1.00.)

Ivins, William M., Jr. *How Prints Look*. (A Metropolitan Museum of Art publication. Beacon Book BP57.) New York: Beacon Press, 1958. (Photographs with a commentary. This will assist you to recognize different techniques. $1.60.)

Keck, Caroline K. *How to Take Care of Your Pictures*. New York: The Brooklyn Museum, 1954. (A concise primer of practical information.

May be ordered from The Brooklyn Museum, Brooklyn, New York, or from the Museum of Modern Art, 11 West 53rd Street, New York, New York. $1.95.)

National Academy of Design Exhibition Record, 1826–1860. 2 vols. New York: The New-York Historical Society, 1943. (Excellent reference material on unfamiliar and familiar artists.)

Pomerantz, Louis. *Is Your Contemporary Painting More Temporary Than You Think?* Chicago: International Book Company, 1962. (Much of the text concerns all paintings and is nice in detail. Order from International Book Company, 332 South Michigan Avenue, Chicago 4, Illinois. $2.15.)

Ruhemann, Helmut, and E. M. Kemp. *The Artist at Work.* Baltimore: Penguin Books, Inc., 1952. (This gives excellent explanations of techniques. $2.00.)

Stout, George L. *The Care of Pictures.* New York: Columbia University Press, 1948. (A more scholarly account than I have given you.)

Studies in Conservation. Quarterly. London: International Institute for the Conservation of Historic and Artistic Works. (Write for information on membership or the purchase of publications in care of The National Gallery, Trafalgar Square, London W. C. 2, England.)

Sugden, Robert. *Packing Instructions for Supervisors, for Packers.* New York, Metroplitan Museum of Art, 1948. (Invaluable. $.25.)

RECOMMENDED CONSERVATORS FOR PAINTINGS

Not all museum conservators are free to assume additional employment. The following persons, listed alphabetically, are known intimately to me; I respect their work and their integrity. If other names are suggested to you, they may be good practitioners. However, check in advance for reliable, objective opinion. Beware of any person who entices your patronage by

proffering as a guarantee of ability a certificate of membership in the International Institute for Conservation. We all belong to this organization for our mutual edification.

DENNIS, Mr. Roger, 100 Mohegan Avenue, New London, Connecticut

ELLIOTT, Mrs. Dorothy Baden, 3655 Egerton Circle, Sarasota, Florida

FISHBURNE, Mr. S. J., Rte. 1, Box 511, New Paltz, New York 12561

HINES, Mr. Felrath, 121 West 88th Street, New York, New York 10024

KIEHART, Mr. Paul, 50 Crest Road, New Hyde Park, L.I., New York

KONRAD, Mr. Anton J., 185 Hall Street, Brooklyn, New York 11205

MICHAELS, Mr. Peter, The Walters Gallery, Baltimore 1, Maryland

PACKARD, Miss Elisabeth, Director of Conservation, The Walters Gallery, Baltimore 1, Maryland

POMERANTZ, Mr. Louis, 1424 Elinor Place, Evanston, Illinois 60201

QUANDT, Mr. Russell J., 3433-34th Street, N.W., Washington 8, D.C.

RABIN, Mr. Bernard, 38 Halsey Street, Newark, New Jersey 07102

ROBERTSON, Mr. Clements L., City Art Museum of St. Louis, St. Louis 5, Missouri

ROCKWELL, Mr. Thornton, Seekonk Road, RD #3, Box 216, Great Barrington, Massachusetts

ROTH, Mr. James, William Rockhill Nelson Gallery of Art, Kansas City, Missouri 64111 (The top expert in the USA on transfer)

SACK, Mrs. Susanne P., 125 Remsen Street, Brooklyn, New York 11201

SIEGL, Mr. Theodor, The Pennsylvania Academy of Fine Arts, Philadelphia, Pennsylvania 19102

VOLKMER, Miss Jean, The Museum of Modern Art, 11 West 53rd Street, New York 19, New York

WATHERSTON, Miss Margaret, 44 West 77th Street, New York 24, New York

ZAGNI, Miss Tosca, The Museum of Modern Art, 11 West 53rd Street, New York 19, New York

RECOMMENDED PAPER CONSERVATORS

GAEHDE, Mrs. Christa, 55 Falmouth Street, Arlington 74, Massachusetts

GLASER, Mrs. Mary Todd, 270 Riverside Drive, New York, New York 10025

HANFT, Mr. William J., The Brooklyn Museum, Brooklyn, New York 11238

TRIBOLET, Mr. Harold W., R. R. Donnelley & Sons Co., 350 East 22nd Street, Chicago 16, Illinois

WEIDNER, Mrs. Marilyn Kemp, 612 Spruce Street, Philadelphia, Pennsylvania 19106

NOTES ON PORTABLE FIRE EXTINGUISHERS

(From a report made by Louis Pomerantz to the *Exposition of Painting Conservation,* held at The Brooklyn Museum, October 1962)

Portable fire extinguishers are designed for use on incipient fires, not for large or deep-seated fires. Fires are best fought when they begin, when they can be prevented from spreading and thus minimize the damage resulting both from the fire and from the extinguishing agent. Extinguishers work by blanketing and cooling; cooling and drenching; blanketing and excluding oxygen; and by depleting oxygen—or combinations of these actions. It is important for museum personnel to know what effect the action of a selected fire extinguisher will have on a work of art as well as its action on the fire.

Fires are divided into classes for listing and rating. Class A fire involves combustibles such as wood and paper. Class B fire involves flammable liquids and greases. Class C fire involves energized electric equipment. Other classes involve metals and reactive chemicals. Portable fire extinguishers are rated according to their effectiveness in combatting different classes of fire, numbers and letters are assigned to each type. The letter refers to the class of fire for which the device is suitable, the number refers to the relative effectiveness of each extinguisher within the same category. For example, a device rated "2A" indicates this extinguisher is

approved for Class A fires and that it has twice the capacity of a device rated "1A". For Class B rated fire extinguishers, the number in front of the letter indicates the approximate square foot area of deep-layer flammable liquid fire which an average operator can extinguish with the device. Letters only, no numbers, are assigned to fire extinguishers suitable for Class C fires. A fire extinguisher is considered suitable only for the class of fire for which it is rated. It is advisable to select only such devices as carry the approved label of the Underwriters' Laboratories or Factory Mutual Laboratories.

The multi-purpose, dry chemical type of extinguisher with pressure gauge for Classes A, B, and C fires, and the Carbon dioxide type (CO_2) appear to be the most desirable devices for museum usage. Water, soda-acid, and chemical solution extinguishers will be effective in combatting certain types of fires but they do great harm to most works of art. The multi-purpose dry chemical type device is lighter in weight than other types of equal rating and also permits the operator to lay down a safe lane by which he can approach the burning object. Tests show this type effective and safe for most works of art of smooth surface, glazed or varnished. The carbon dioxide device is also efficient and appears more advantageous in use on unvarnished, unglazed and textured surfaced art objects. This device however, requires closer working distance, the "snow" from it can accumulate and present a subsequent cleaning difficulty, and the vapors from its usage are toxic in unventilated and confined areas. All personnel should be trained to know location of and method of using the selected fire extinguishers.

Further information can be obtained from:

National Fire Protection Association, International, NFPA No. 10, "Standard for the Installation, Maintenance and Use of Portable Fire Extinguishers," May 1961, ($1.00) NFPA, 60 Batterymarch Street, Boston 10, Mass.

National Fire Protection Association, International, NFPA No. PL-4, "Publications on Fire Prevention and Protection," (single copy free)

Consumers Union of the US, "Dry Chemical Fire Extinguishers" *Consumer Reports,* July 1962, pp. 340–343.

❧ Index